CANTON & PONTCANNA

CANTON & PONTCANNA

MARK HAWKINS

The
History
Press

First published 2018

The History Press
The Mill, Brimscombe Port
Stroud, Gloucestershire, GL5 2QG
www.thehistorypress.co.uk

British Library Cataloguing in Publication Data.
A catalogue record for this book is available from the British Library.

ISBN 978 0 7509 8814 8

Typesetting and origination by The History Press
Printed and bound in China.

INTRODUCTION

Cardiff city centre and Cardiff Bay grab the spotlight with their unmistakably iconic architecture: Cardiff Castle, the Principality Stadium, Wales Millennium Centre and the Senedd building. They have the entertainment hotspots, the city's key symbols. They don't, however, reflect the full picture of Cardiff. Any city is the sum of its many parts, from the outer suburban reaches, the woodlands and parklands, to inner districts and communities.

Canton and Pontcanna are two unique neighbouring districts and gateways into Cardiff's city centre. Their communities represent the day-to-day life of the city as much as the activity of the city's hub. Their streets are full of life, with residents shopping, working, playing, passing time or simply travelling through on their way in and out of the city.

Inner suburbs retain a degree more authenticity because they change less, because they are not constantly and radically developing alongside the city centre. The streets and pubs and shops and parks stay relatively unchanged for longer periods of time. Being located closer to the centre perhaps makes them less vulnerable to the development faced by their outer suburban cousins. They experience a less interrupted flow of life.

Within Cardiff, if you say you live in Pontcanna it is likely to elicit a certain reaction. People might raise an eyebrow, impressed in one way or another. It is known as an affluent, exclusive area, a place for media workers, thanks in part to a large BBC headquarters that has been based a short distance away in Llandaff for a number of years (though before long it will move to a purpose-built city-centre location).

Pontcanna feels like a village – leafy, close and comfortable. It is simple to navigate with the straight, tree-lined Cathedral Road flowing directly into the city centre. Just off this thoroughfare is Pontcanna Fields, a thumping green heartbeat of Cardiff and home to countless football, rugby and cricket matches played adjacent to the River Taff.

Canton is considerably larger and more diverse. Hooked around the main retail and leisure street of Cowbridge Road, it sprawls from Cardiff city centre towards the district of Ely and has indistinct borders with Grangetown, Pontcanna and Llandaff. While it maintains a steadfast working-class heritage, Canton is also now home to young professionals and creative people, with Chapter Arts Centre a local cornerstone of culture and entertainment.

In researching historical details for inclusion in this book, the author felt conflicted. Anyone can use the Internet to quickly find historical details and such details might offer wider historical context and deeper interest – more of a story. But in those details you can equally get lost, confused and ultimately bored. How much can be known about local events of hundreds of years ago, from here in 2018 – the era of 'fake news'? There will always be an expert available in a local pub to confidently challenge information you heard with equally convincing authority elsewhere.

It seems a shame because local people of Canton and Pontcanna can be incredibly generous with their time, stories and information. When you tell people you are working on a book about the area (because you have to say *something* to explain why you are walking around with a camera taking pictures), people enthusiastically offer you new nuggets of information. Hopefully the photographs will do most of the talking over the following pages to give a faithful modern reflection of these great Cardiff communities.

TIMES OF DAY:

NOTE FROM THE AUTHOR

This book is divided into five chapters: Streets, Culture, Faith, Moments and Parks. Each image caption is stamped with the time of day it was captured.

Mark Hawkins, Cardiff, 2018

STREETS

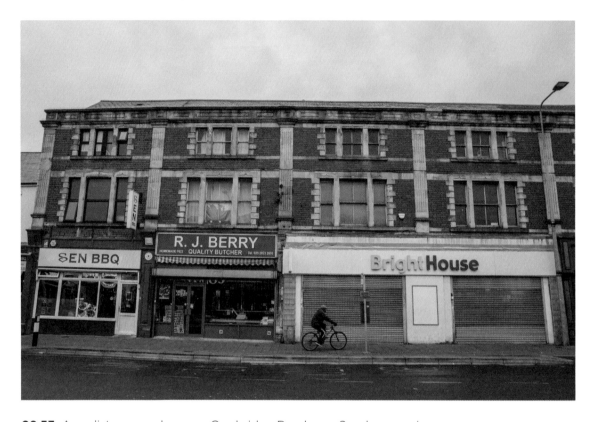

08.53: A cyclist passes shops on Cowbridge Road on a Sunday morning

08.57: The Corporation pub, on the junction of Cowbridge Road East and Llandaff Road, in the middle of Canton

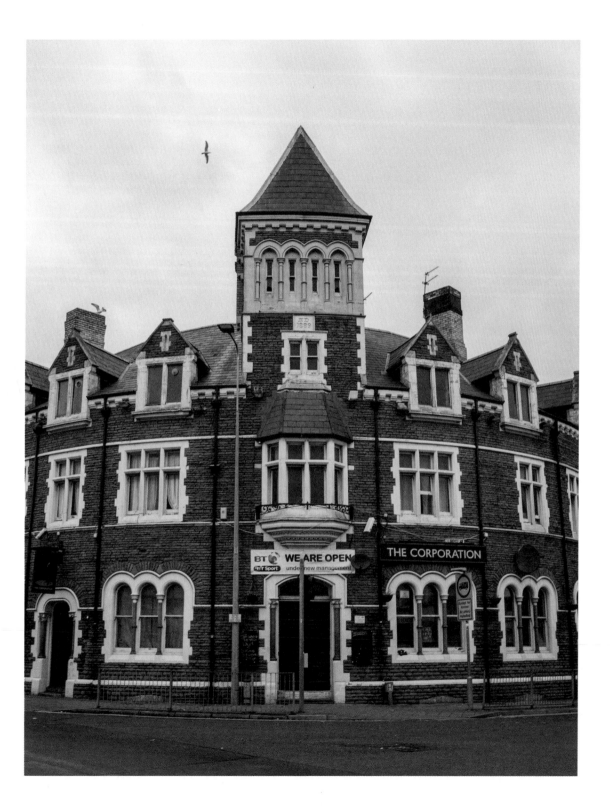

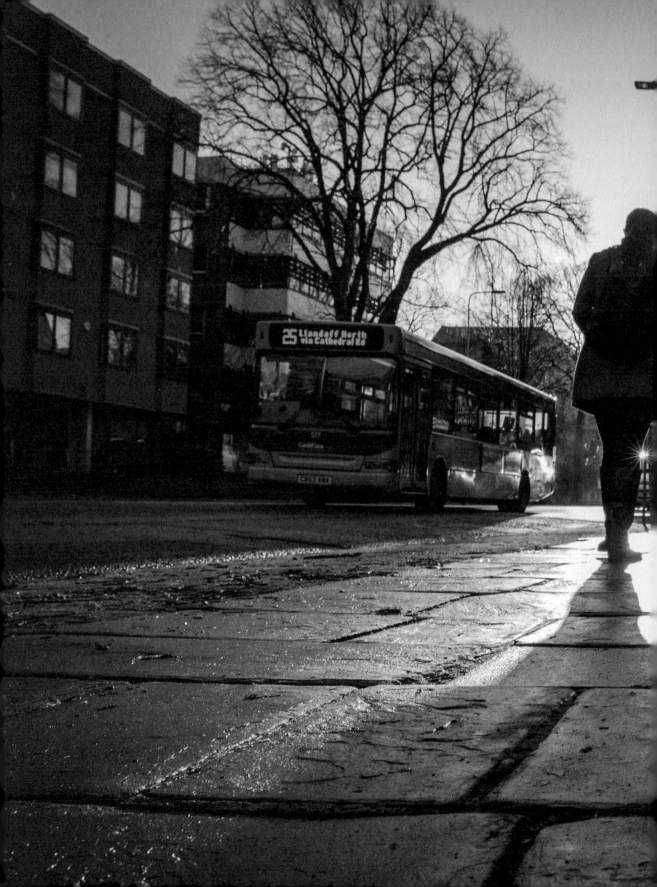

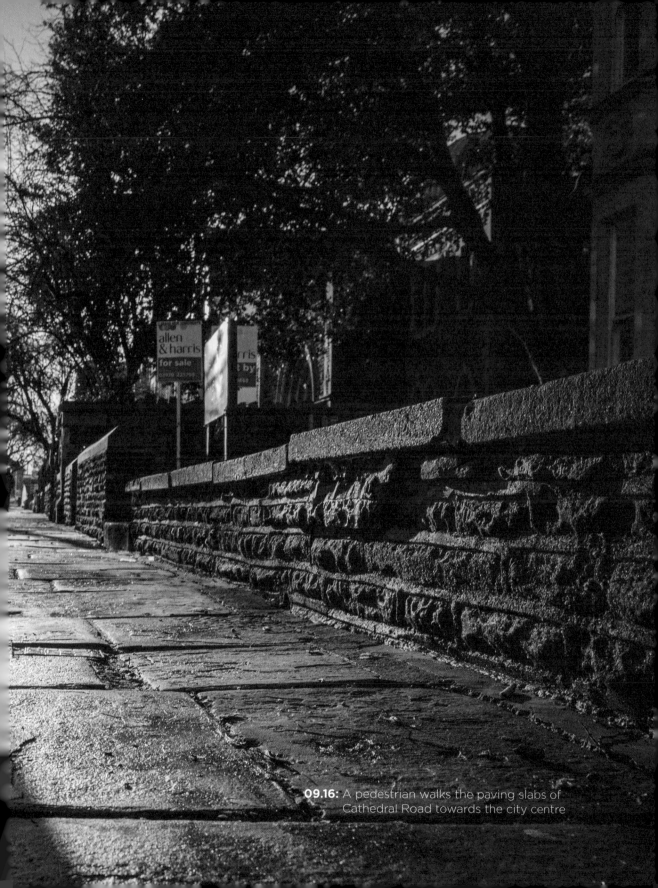

09.16: A pedestrian walks the paving slabs of Cathedral Road towards the city centre

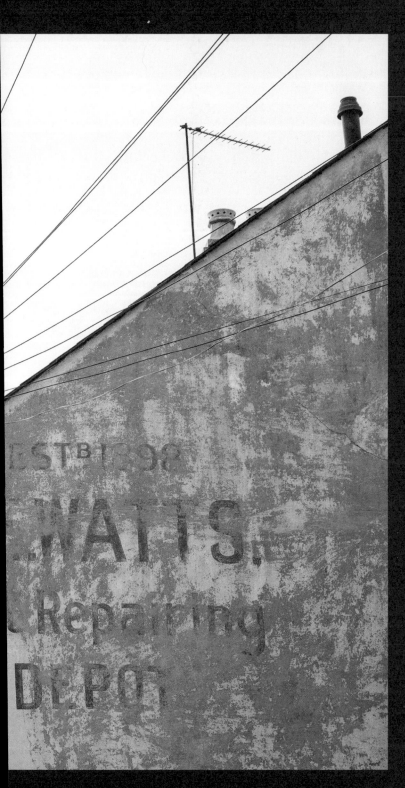

09.40: Markings on a Kings
Road building read
'Est B 1898. CE Watt
Boot Repairing Depo

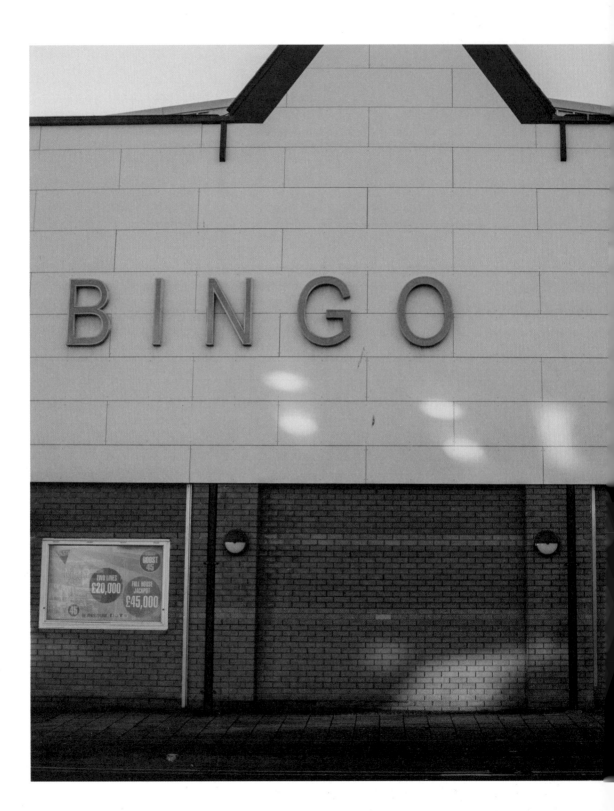

10.04: A pedestrian walks
past a Bingo hall on
Cowbridge Road

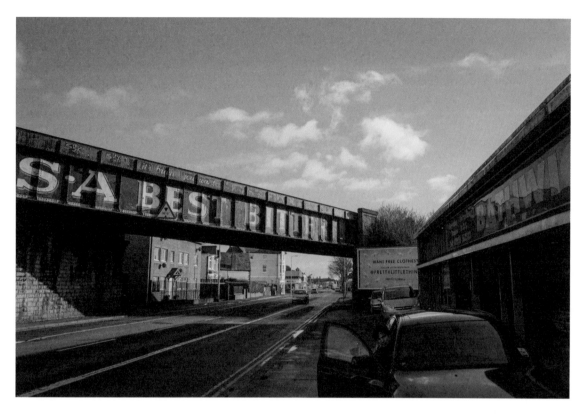

11.33: A railway bridge advertising SA Best Bitter of Brains Brewery and garage Bathwick Tyres on Lansdowne Road, near Victoria Park

10.19: Buildings on Cathedral Road reflected in a puddle

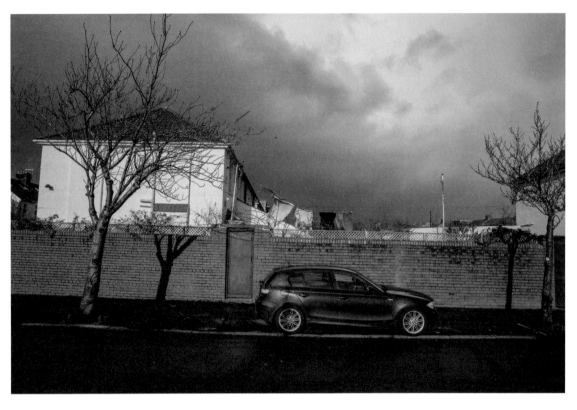

11.40: A residential street view of a car and washing line on Windway Avenue

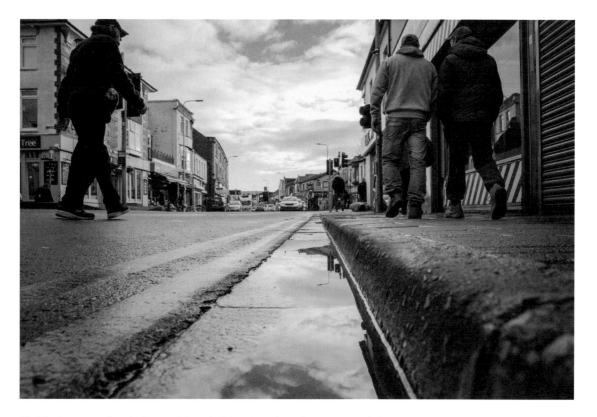

11.49: A gutter-level view of Cowbridge Road in the centre of Canton

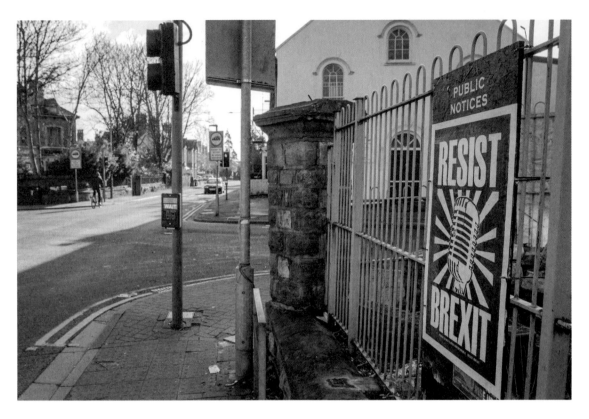

11.50: 'Resist Brexit' reads a public noticeboard on Llandaff Road

12.01: A man appears to check the latest betting odds in the Victoria Park pub

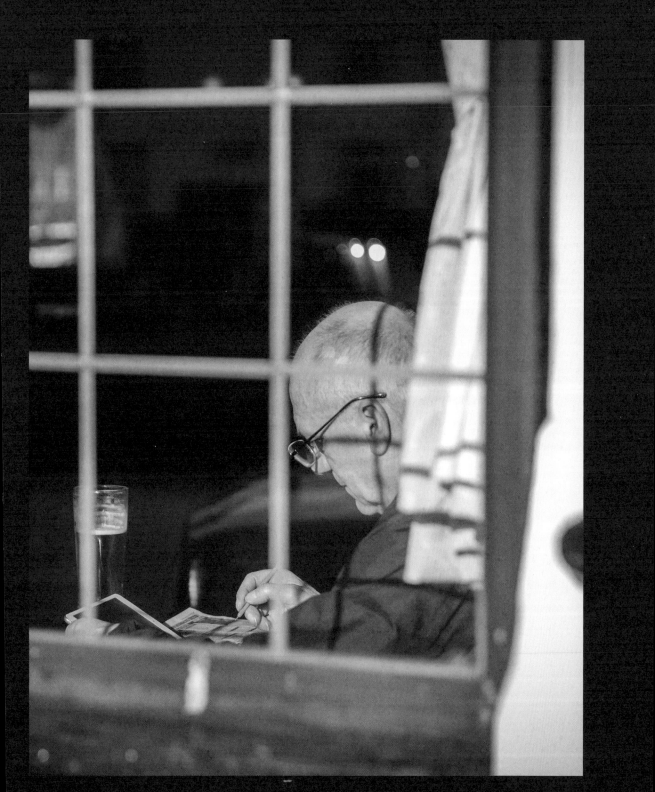

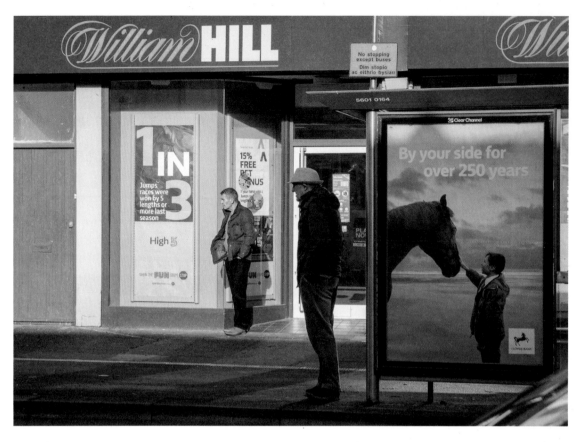

12.02: Men wait for a bus outside a betting shop on Cowbridge Road

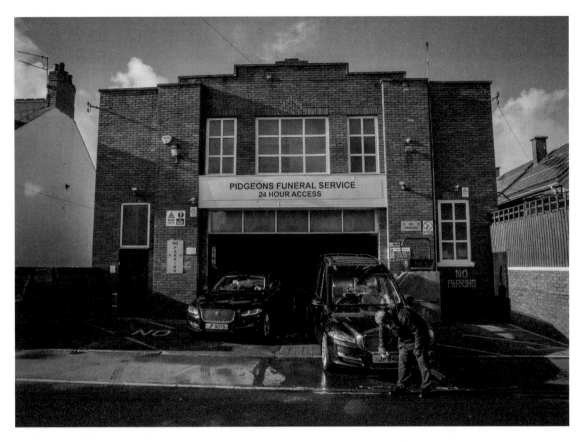

12.04: Vehicles of Pidgeons Funeral Service at their base

12.07: A man sits on a Cardiff bus travelling along Cowbridge Road East towards the city centre

cludiant campus

EMERGENCY EXIT break glass
ALLANFA ARGYFWNG torrwch y gwydr

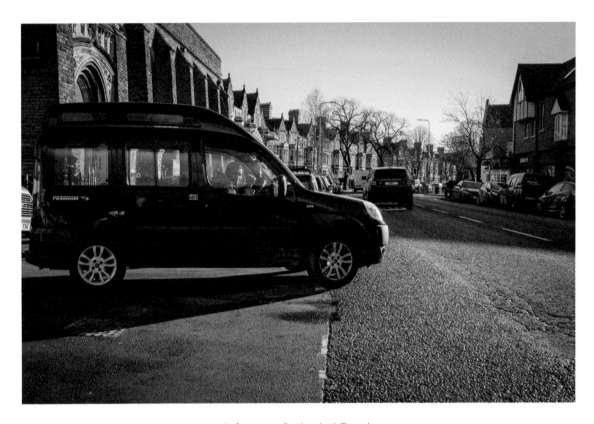

12.16: A taxi driver prepares to turn left on to Cathedral Road

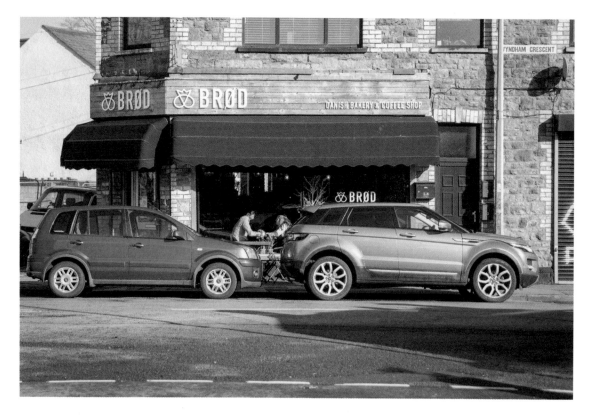

12.19: A couple sit at a window of Brød, a danish bakery and coffee shop on Wyndham Crescent

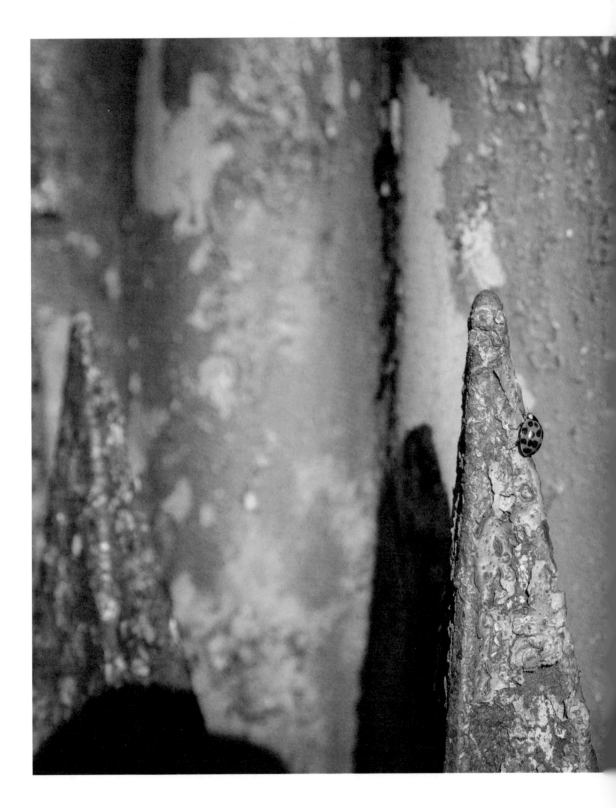

12.47: A ladybird explores the flaked paint of a rusty railing on Llandaff Road

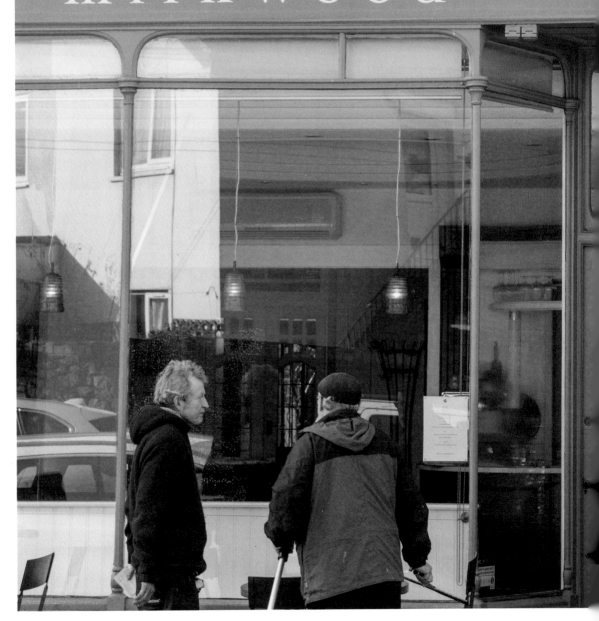

12.51: The proprietor of Milkwood restaurant on Pontcanna Street speaks with a window cleaner and a passer-by

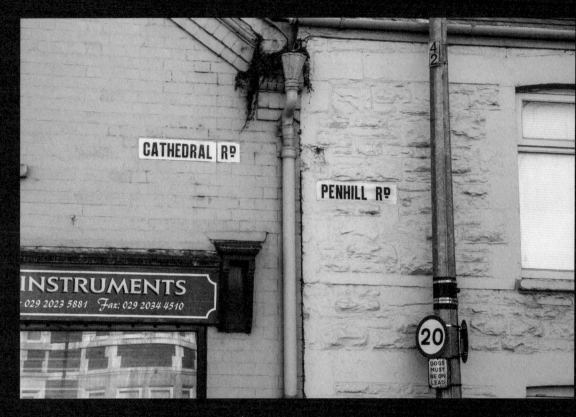

13.06: The border of Cathedral Road and Penhill Road in Pontcanna

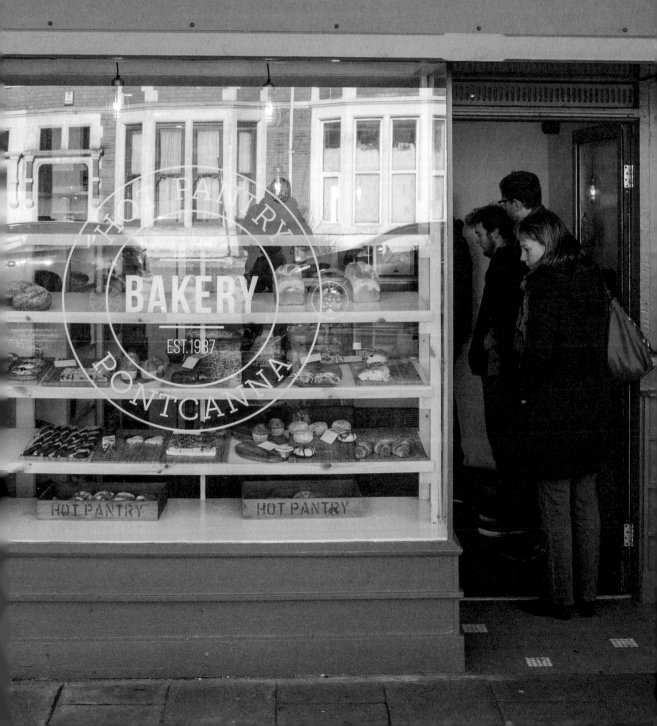

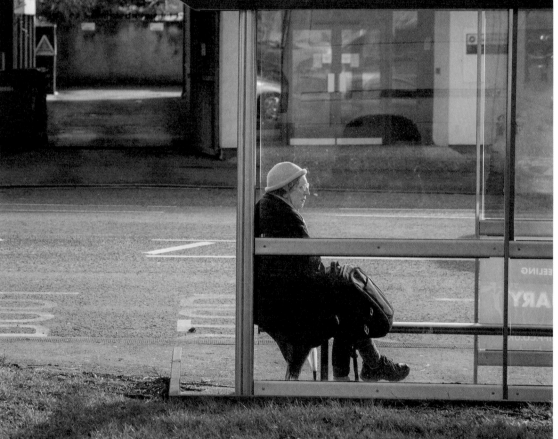

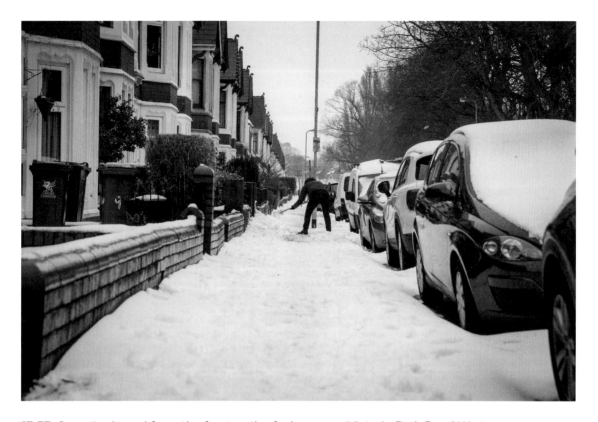

13.57: Snow is cleared from the front path of a house on Victoria Park Road West

13.18: A woman waits at a bus stop on Penhill Road

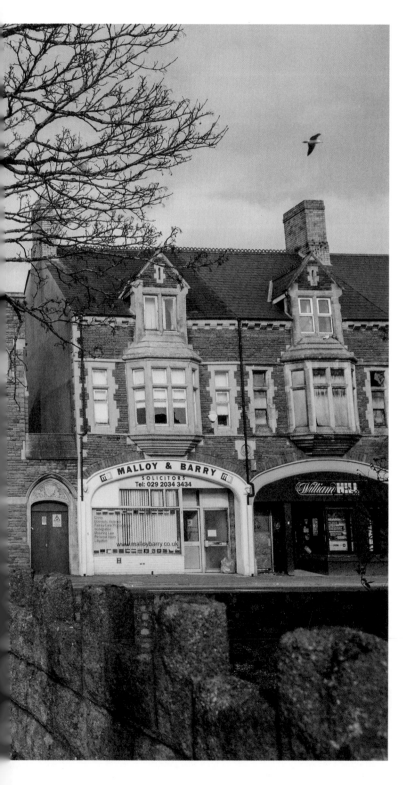

14.03: A street view of Cowbridge Road East, with Canton Library in the centre

14.26: A motorcyclist passes a fancy dress shop on Leckwith Road

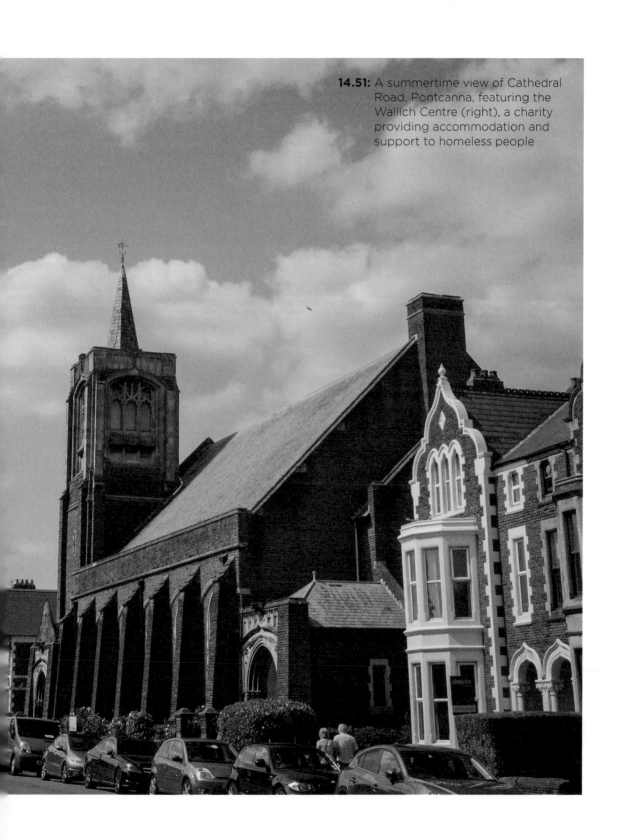

14.51: A summertime view of Cathedral Road, Pontcanna, featuring the Wallich Centre (right), a charity providing accommodation and support to homeless people

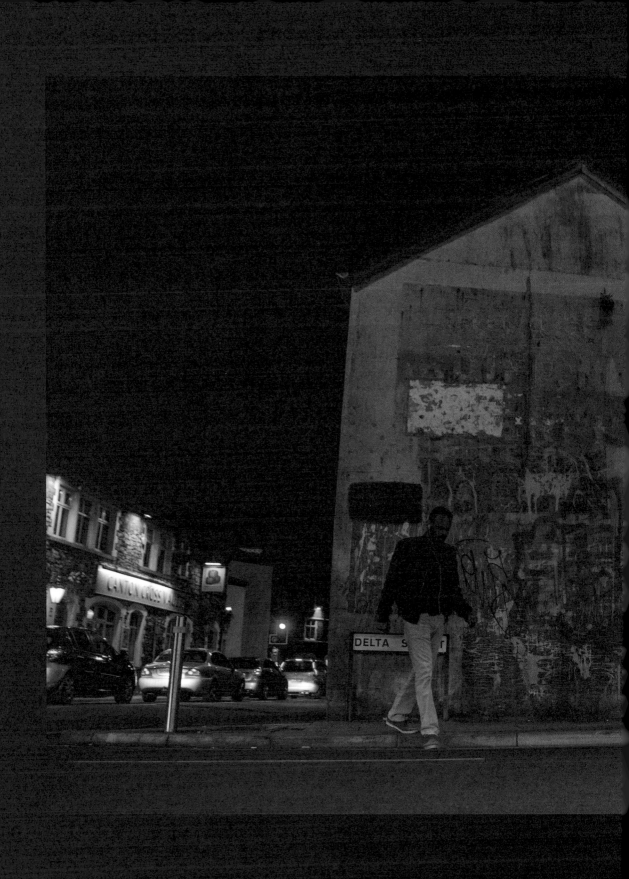

20.47: A man crosses Delta Street in Canton

CULTURE

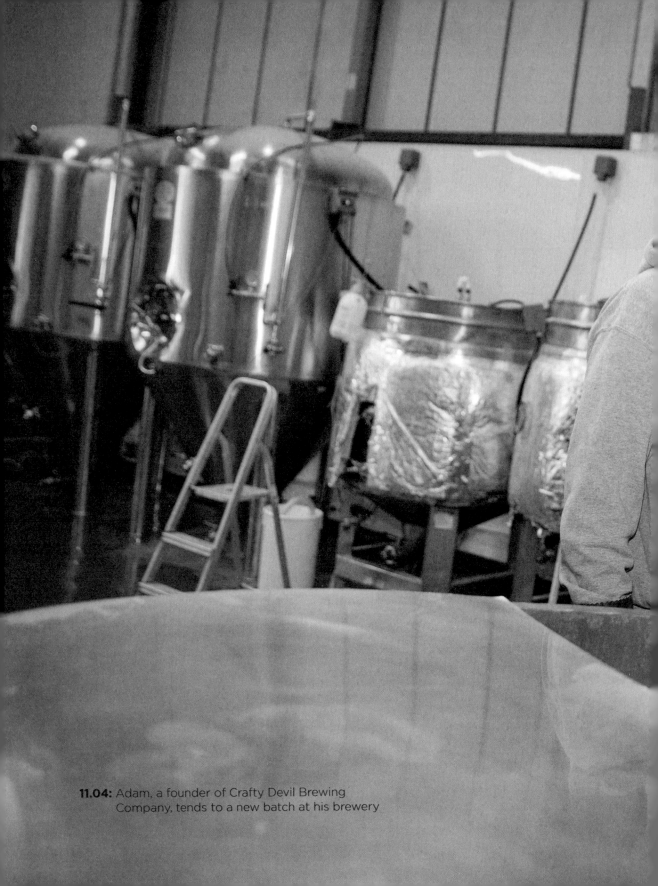

11.04: Adam, a founder of Crafty Devil Brewing
Company, tends to a new batch at his brewery

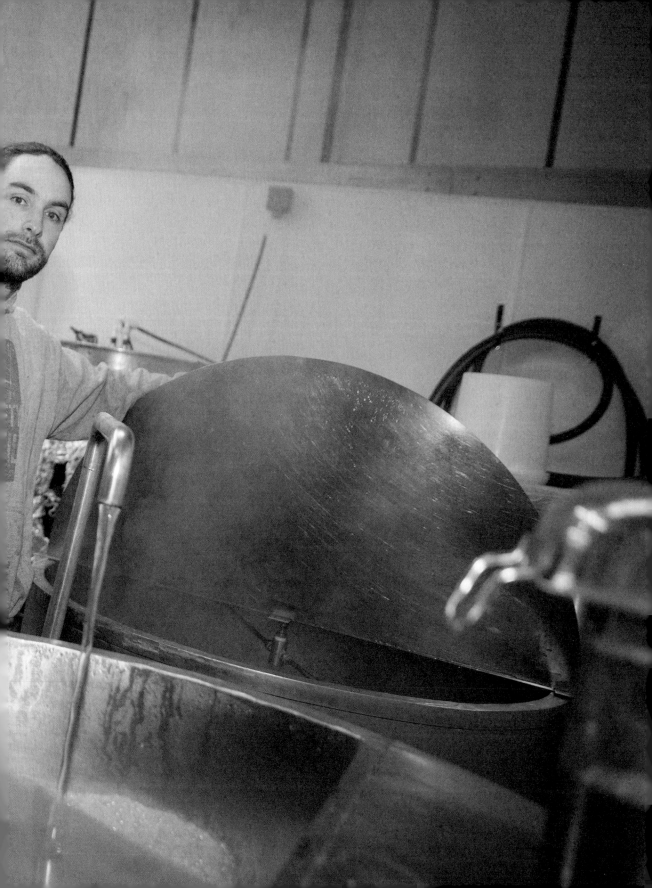

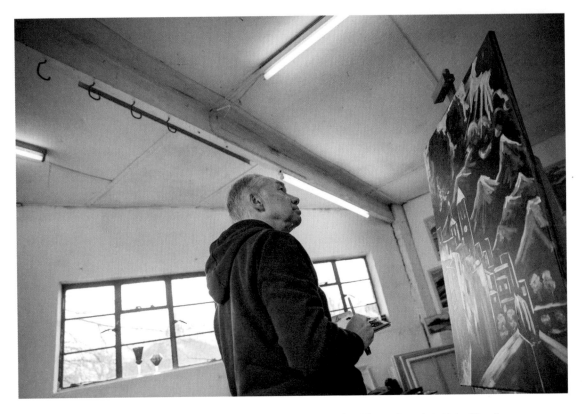

11.18: Artist Martin Briggs works on his latest painting at the Kings Road Artists Studios

11.28: Artist Jan Williams at work in her studio at the Kings Road Artists Studios

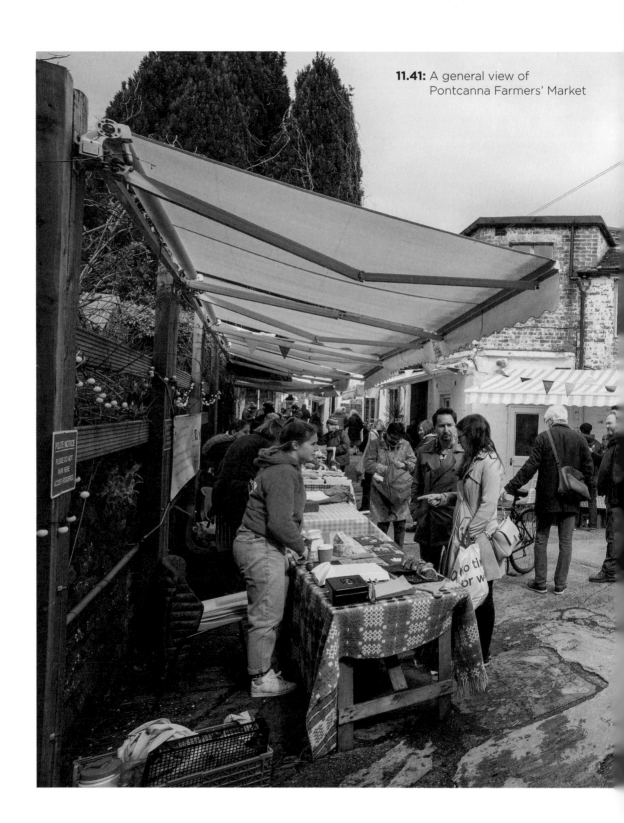

11.41: A general view of Pontcanna Farmers' Market

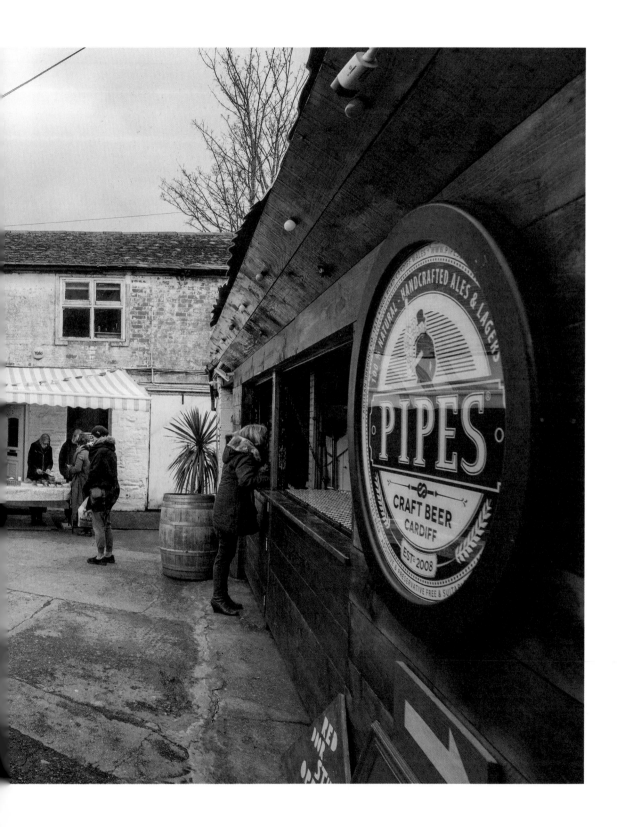

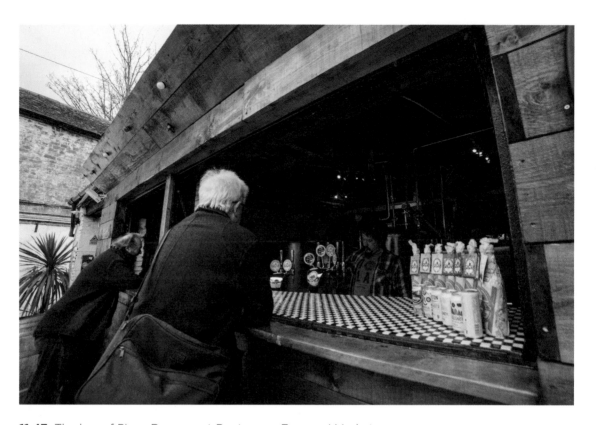

11.47: The bar of Pipes Brewery at Pontcanna Farmers' Market

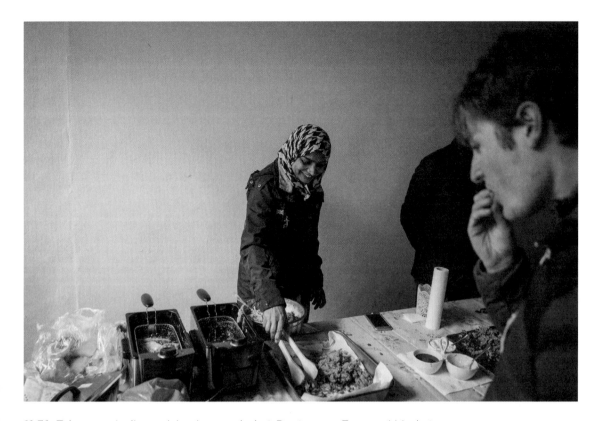

11.51: Takeaway Indian cuisine is sampled at Pontcanna Farmers' Market

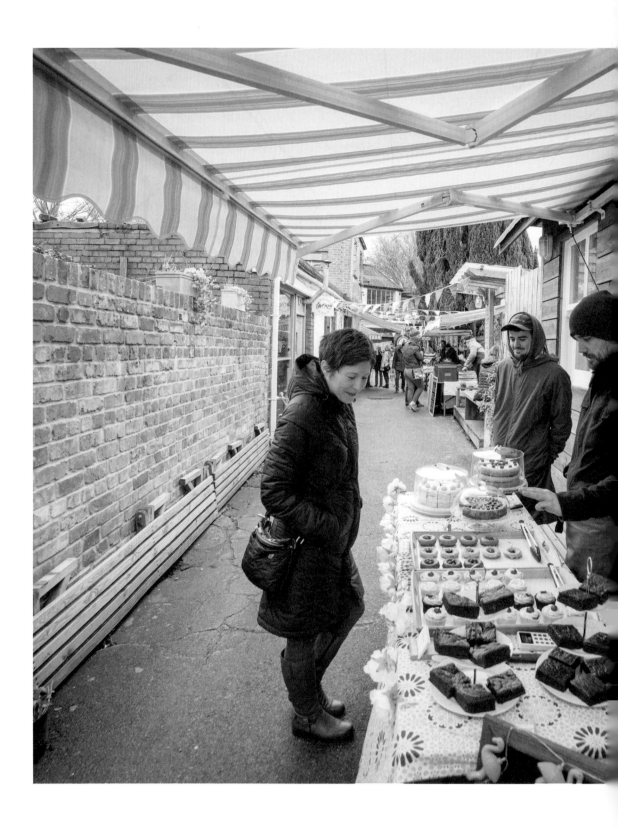

11.56: A customer attempts to decide at Vegan Treats by Lazy Leek at Pontcanna Farmers' Market

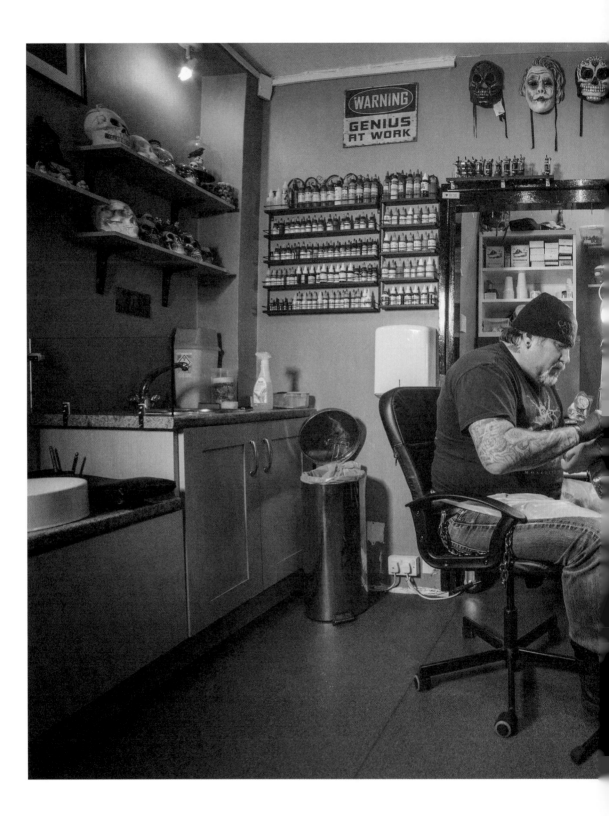

12.24: Tattooist Jay Robinson works on customer Will at the Cardiff Ink Tattoo Emporium in Pontcanna

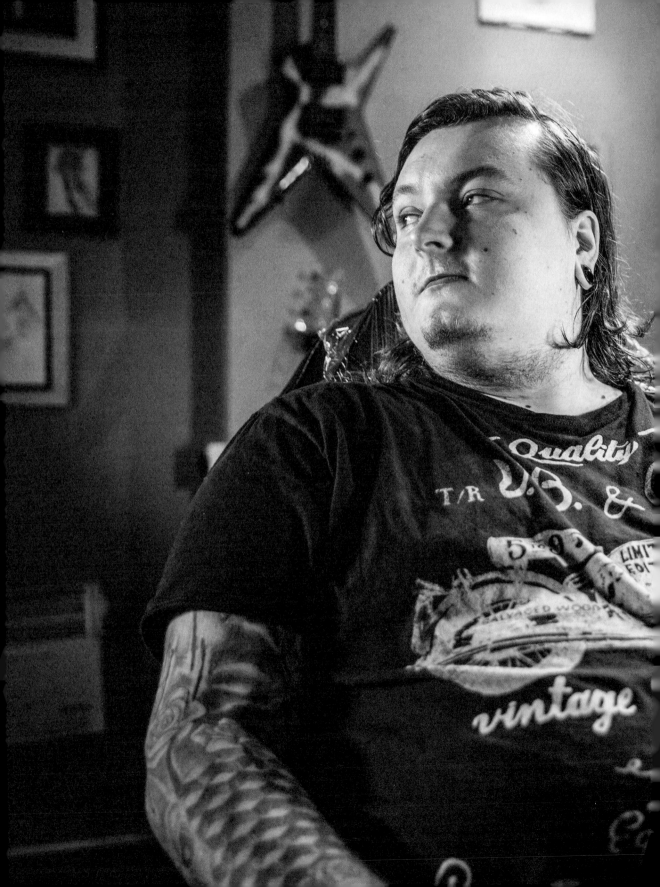

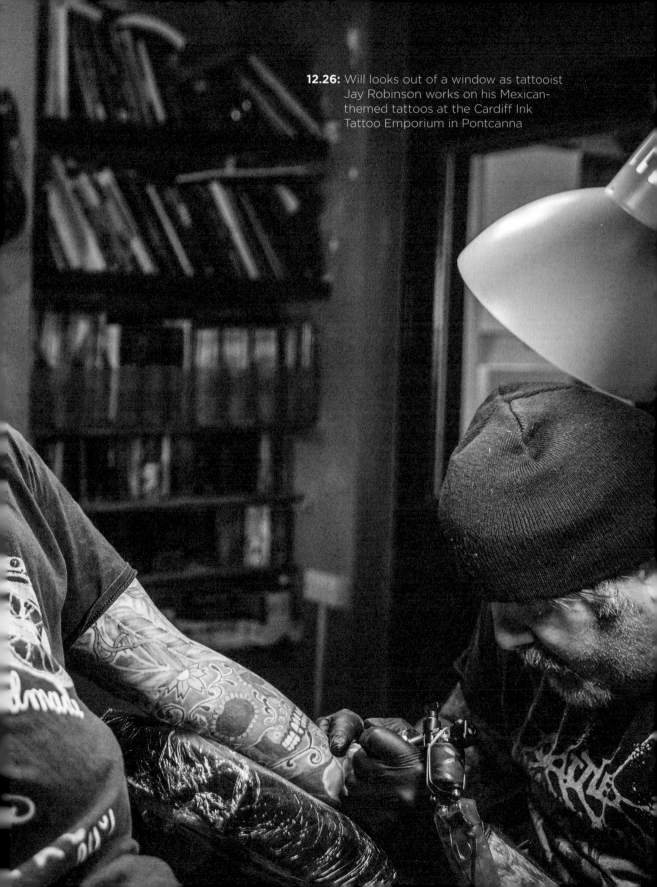

12.26: Will looks out of a window as tattooist Jay Robinson works on his Mexican-themed tattoos at the Cardiff Ink Tattoo Emporium in Pontcanna

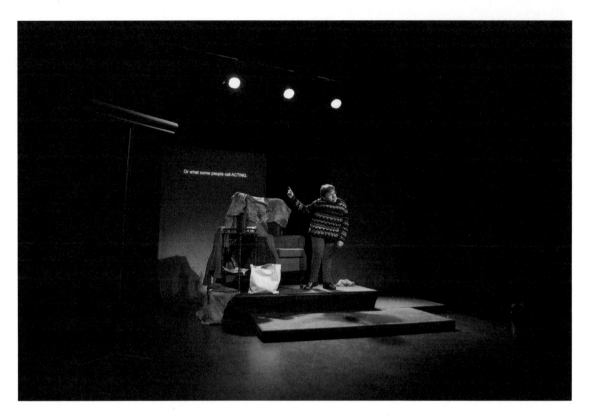

13.15: Sara Beer rehearses for 'Richard III Redux' OR 'Sara Beer (is/not) richard III' from The Llanarth Group at Chapter Arts Centre

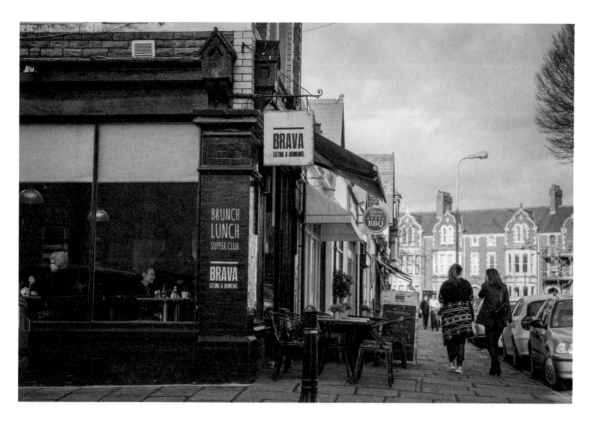

13.24: A row of busy restaurants on Pontcanna Street at lunchtime

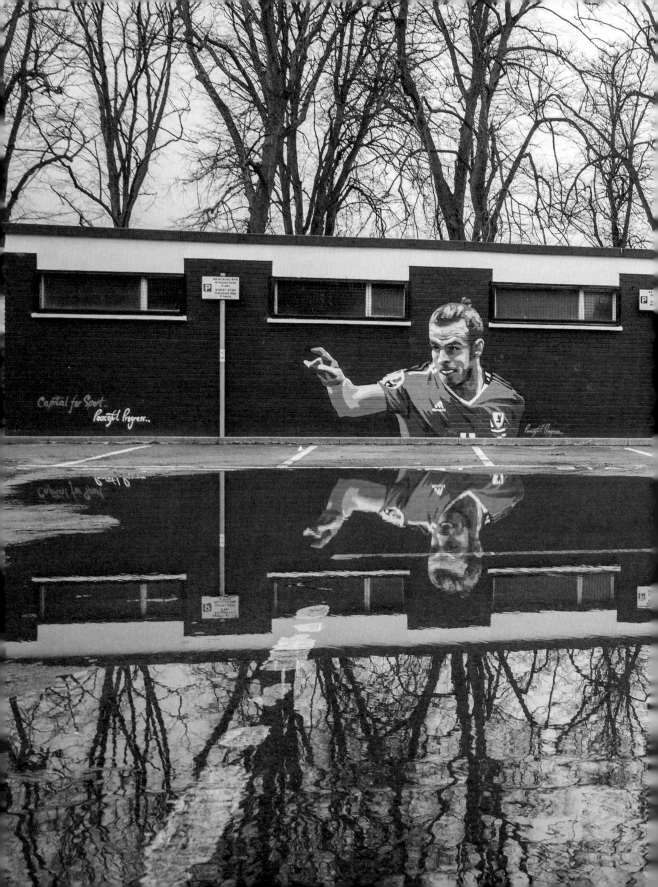

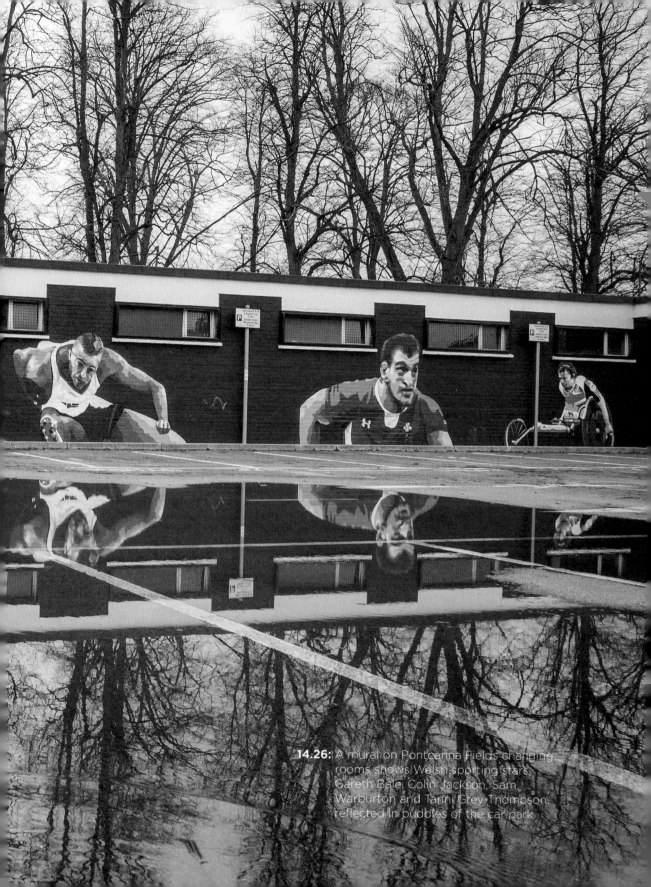

14.26: A mural on Pontcanna Fields changing rooms shows Welsh sporting stars Gareth Bale, Colin Jackson, Sam Warburton and Tanni Grey-Thompson reflected in puddles of the car park

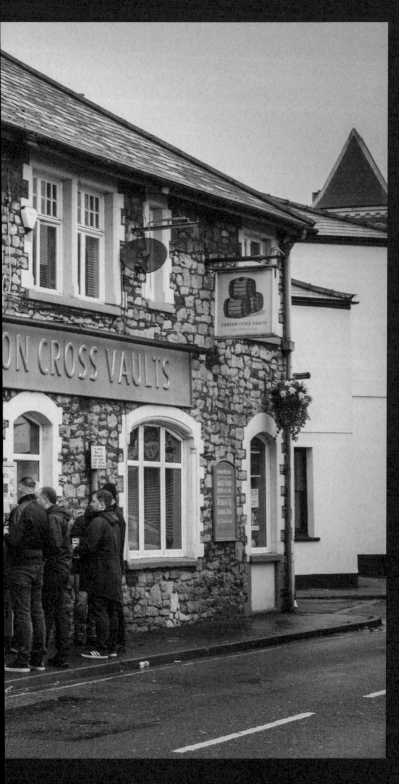

14.36: Men drink outside the Canton Cross Vaults pub before an FA Cup fourth round match between Cardiff City and Manchester City

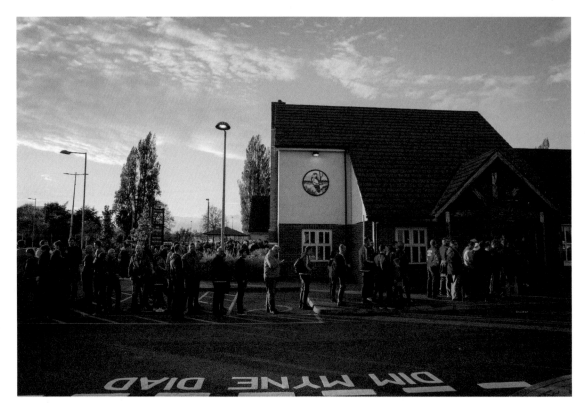

17.40: Football fans queue outside the Sand Martin pub before the World Cup qualification match between Wales and the Republic of Ireland

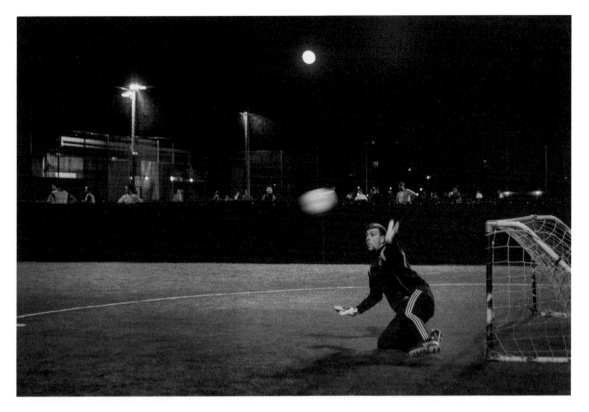

20.11: A goalkeeper attempts to save a shot at the Gôl 5-a-side and 7-a-side football centre on Lawrenny Avenue

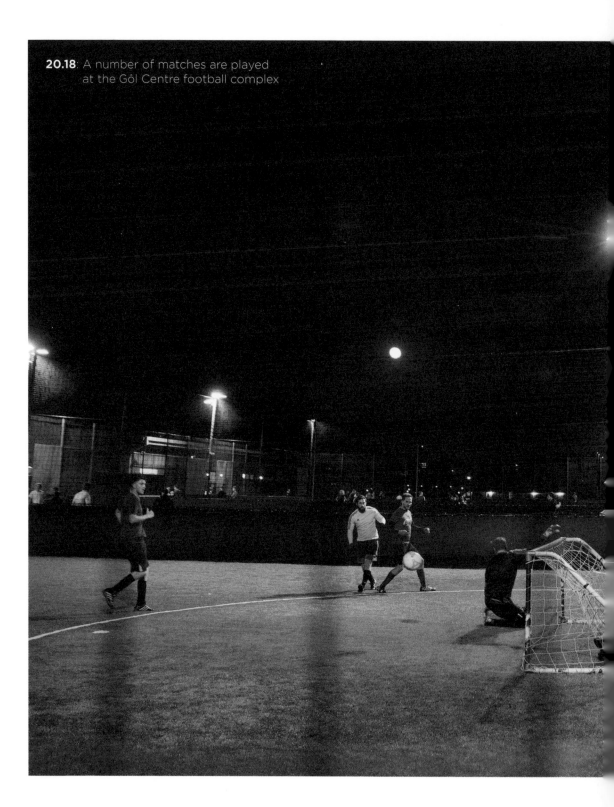

20.18: A number of matches are played at the Gôl Centre football complex

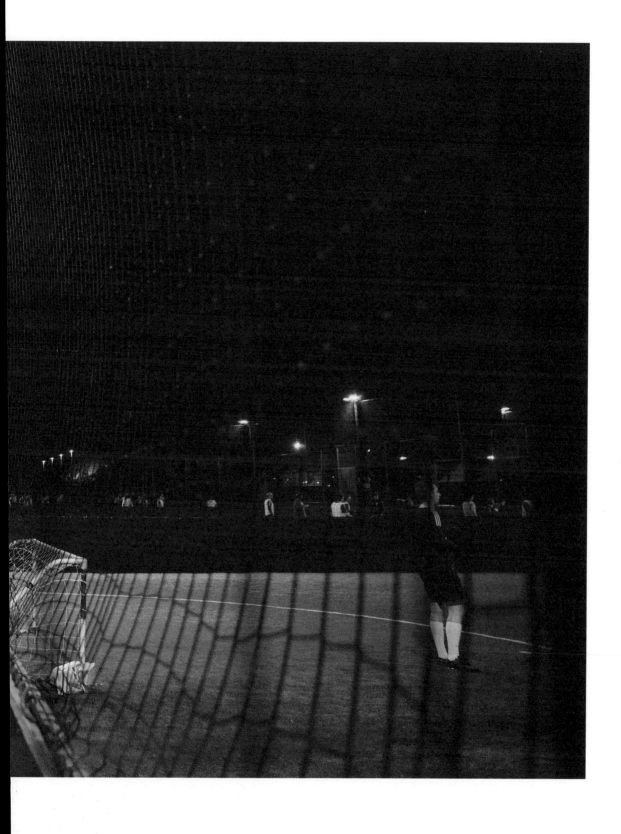

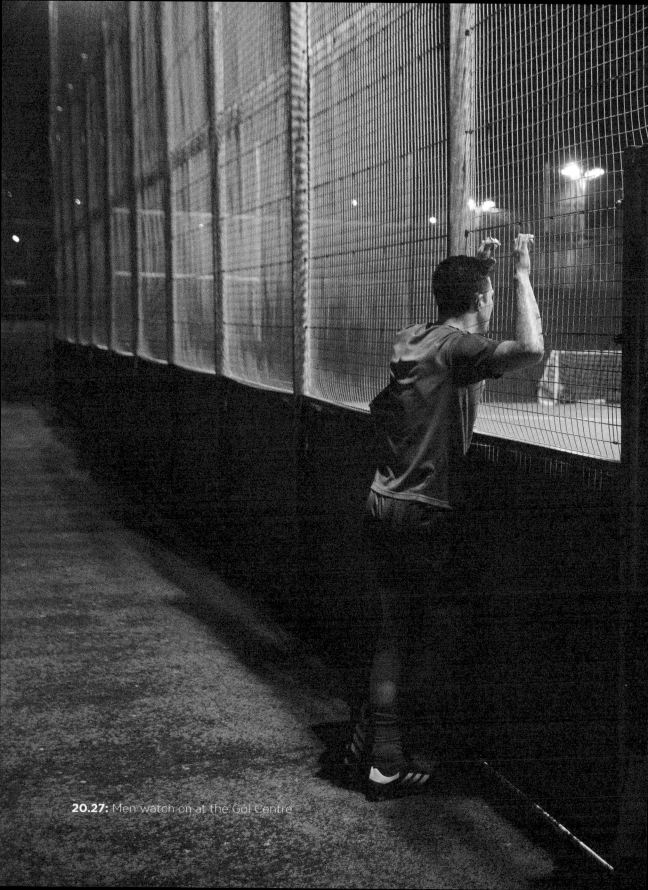
20.27: Men watch on at the Gol Centre

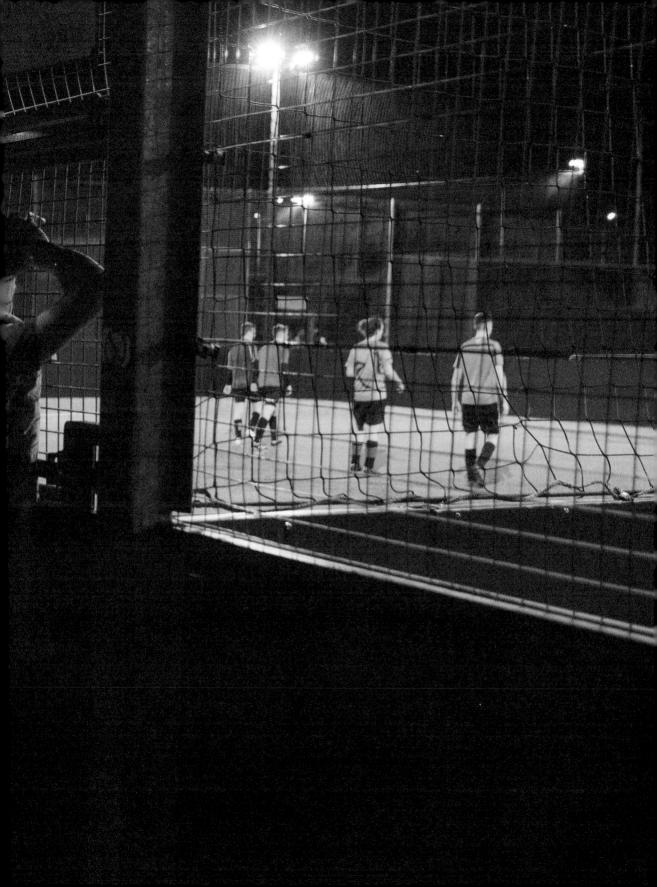

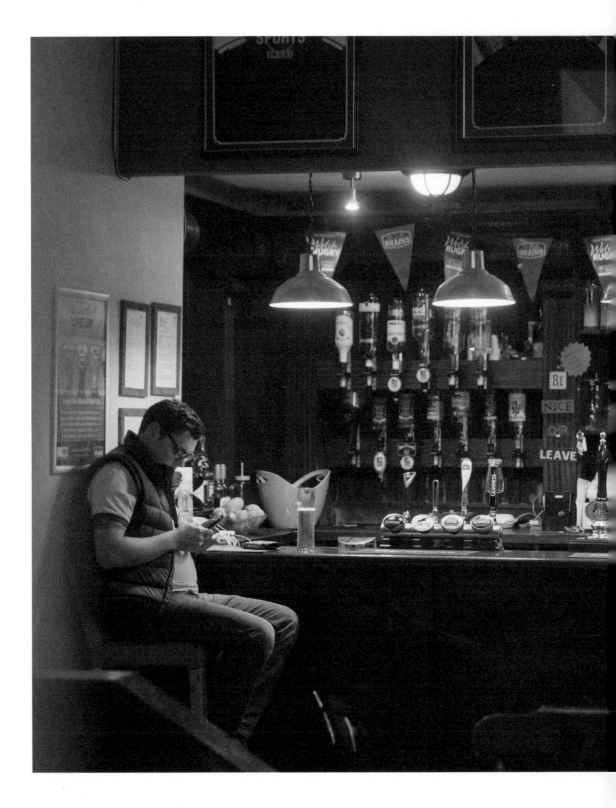

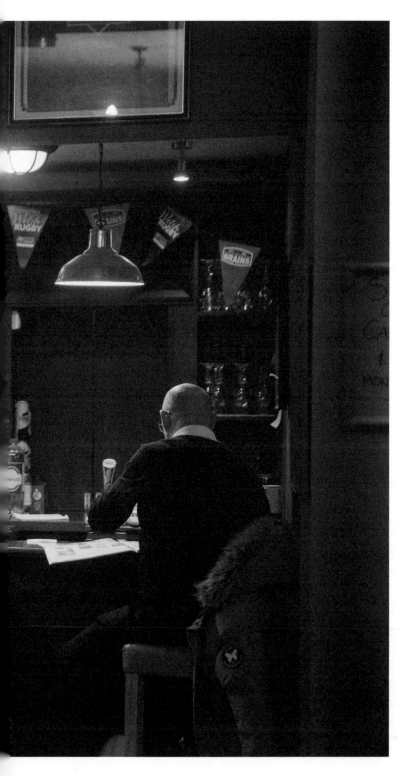

20.45: A quiet scene in the Canton pub

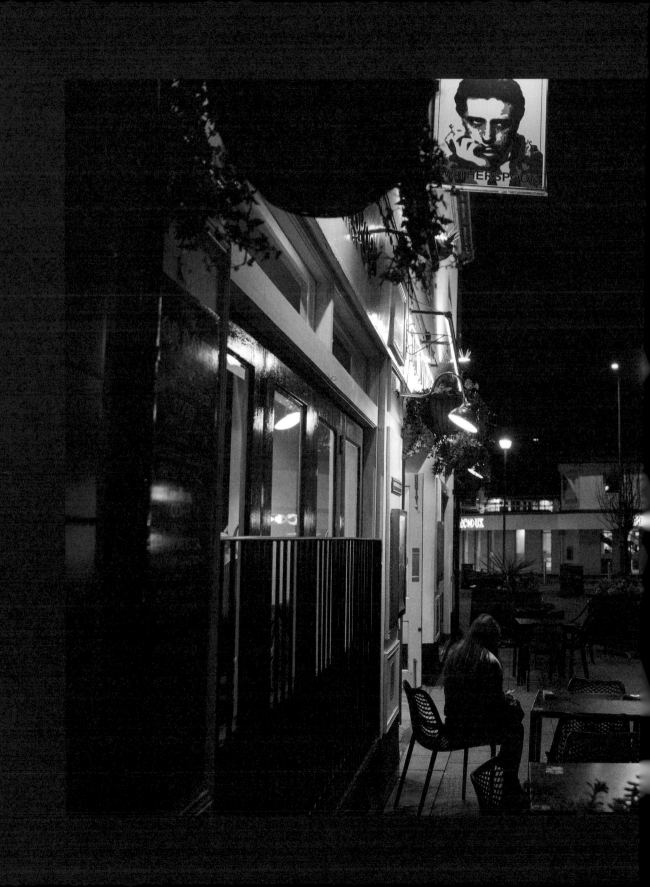

20.48: A woman smokes a cigarette outside the Ivor Davies, a Wetherspoons pub on Cowbridge Road East

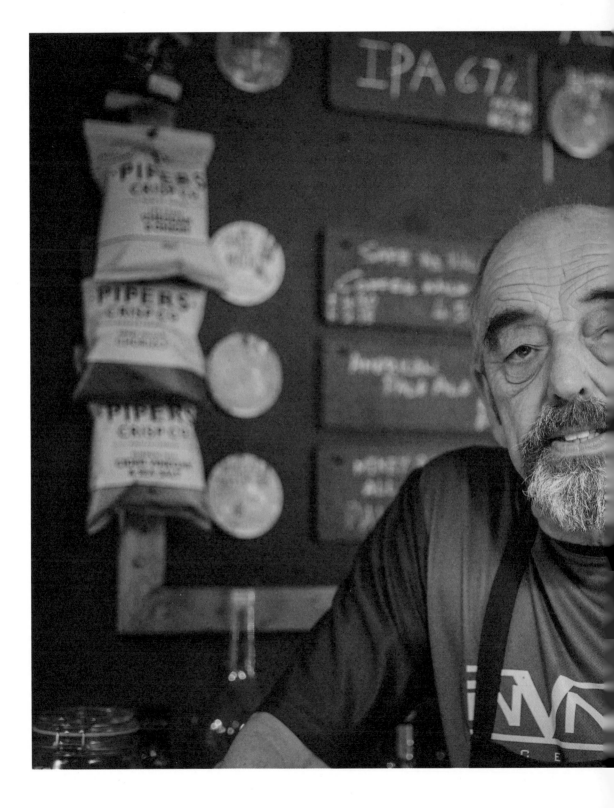

20.52: Gareth, a barman at the Crafty Devil Cellar Bar & Shop

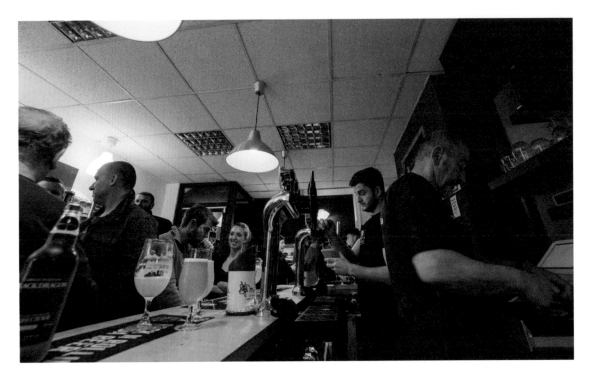

20.55: A general Friday night view across the Crafty Devil Cellar Bar

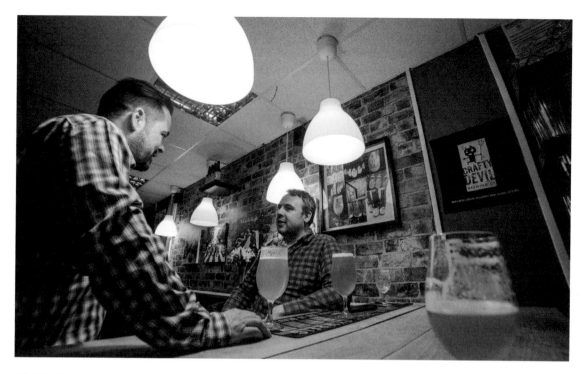

20.58: Two men chat over ales at the Crafty Devil Cellar Bar

FAITH

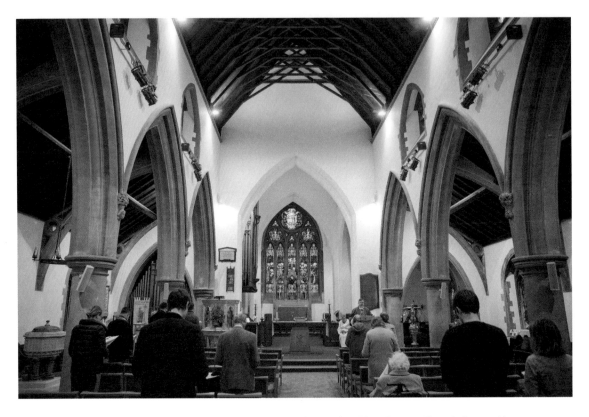

09.58: A Sunday morning service at the Church of St John The Evangelist, delivered by Canon Mark Preece, Rector of Canton

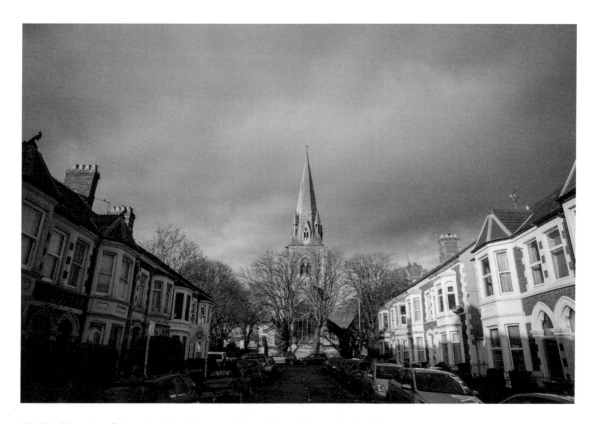

10.22: Church of St John The Evangelist, pictured from Earle Place

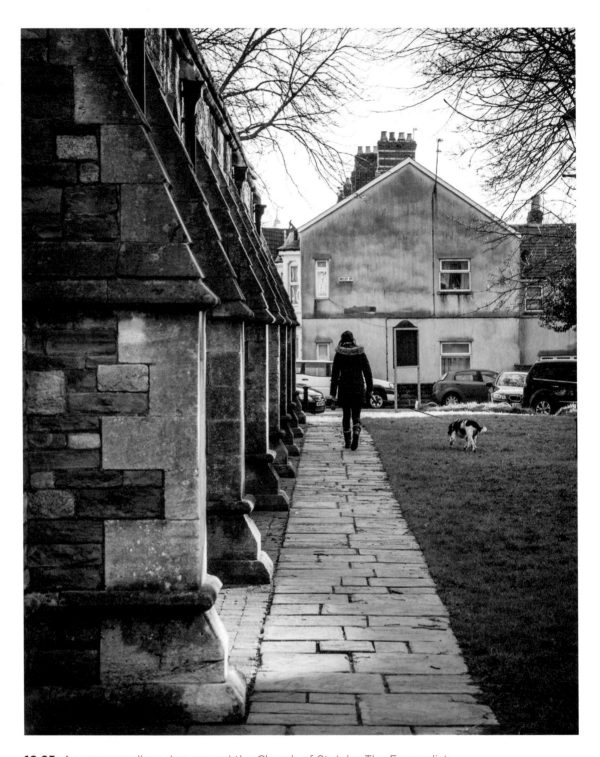

10.25: A woman walks a dog around the Church of St John The Evangelist

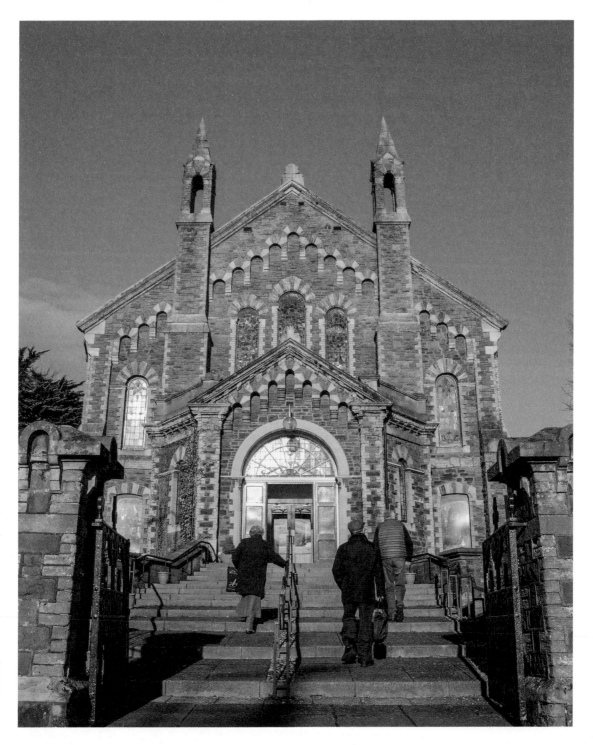

10.44: Members of the congregation arrive for a Sunday service at Conway Road Methodist Church

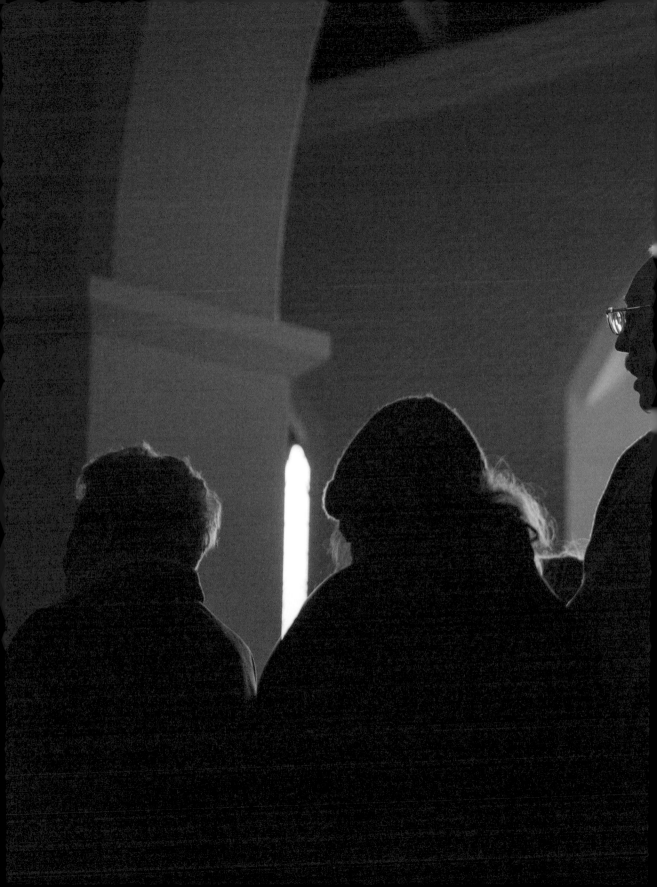

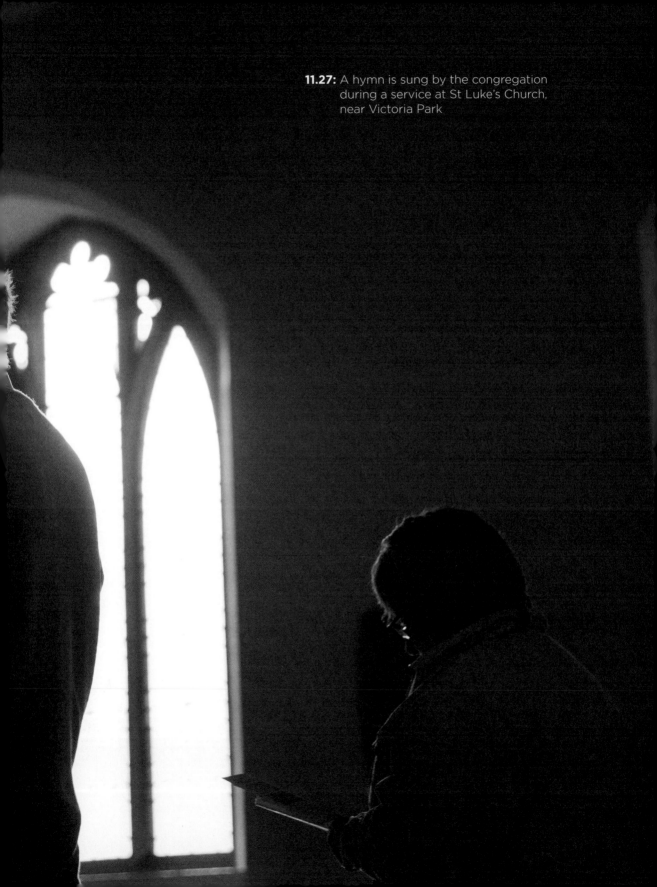

11.27: A hymn is sung by the congregation during a service at St Luke's Church, near Victoria Park

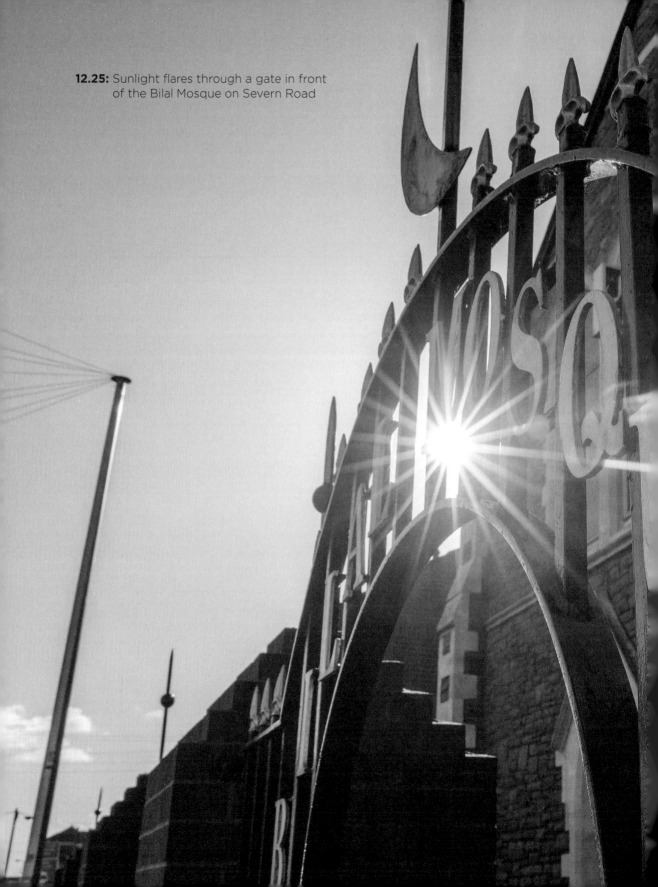

12.25: Sunlight flares through a gate in front of the Bilal Mosque on Severn Road

MOMENTS

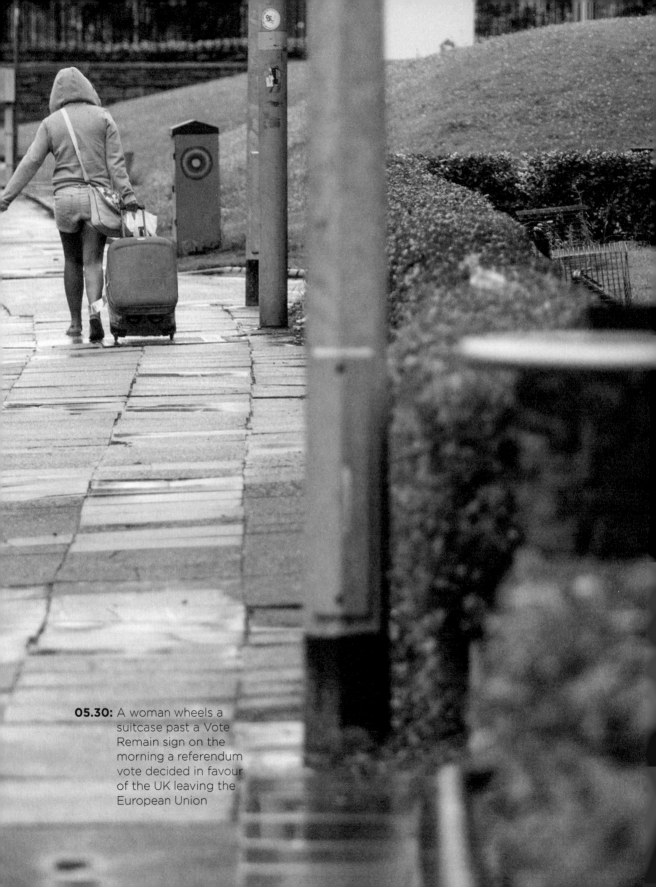

05.30: A woman wheels a suitcase past a Vote Remain sign on the morning a referendum vote decided in favour of the UK leaving the European Union

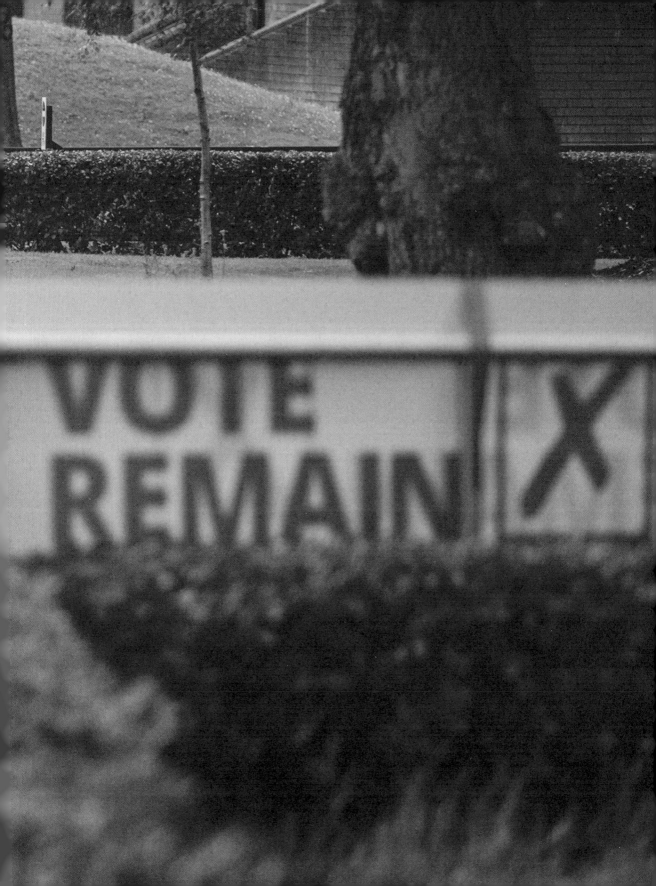

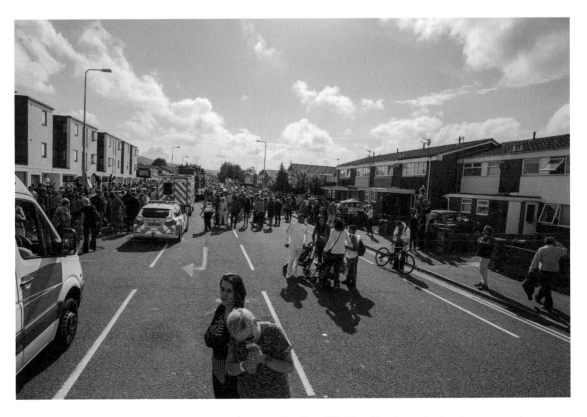

17.19: Football fans follow an open-top bus to the Cardiff City Stadium during homecoming celebrations for the Wales Euro 2016 squad, which reached the semi-final stage

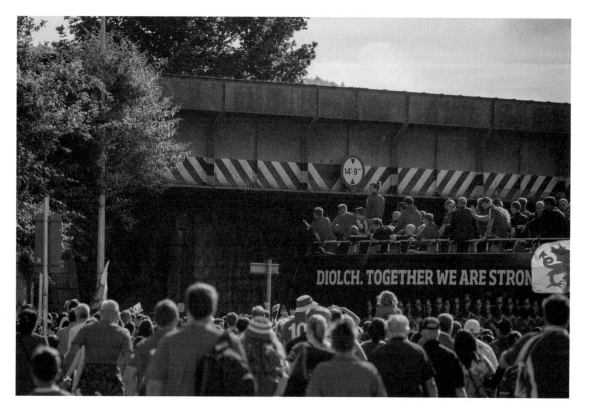

17.29: An open-top bus passes beneath a Canton railway bridge on the way to the Cardiff City
Stadium for Euro 2016 homecoming celebrations

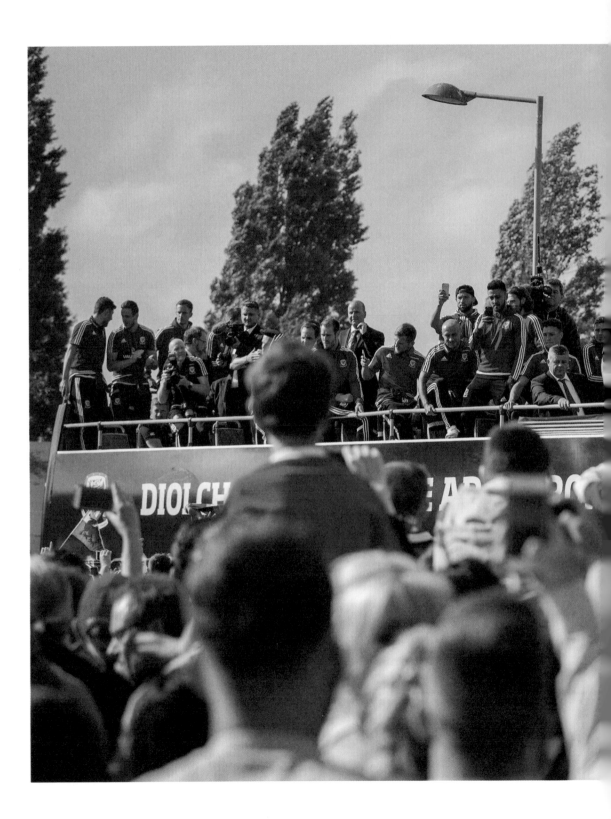

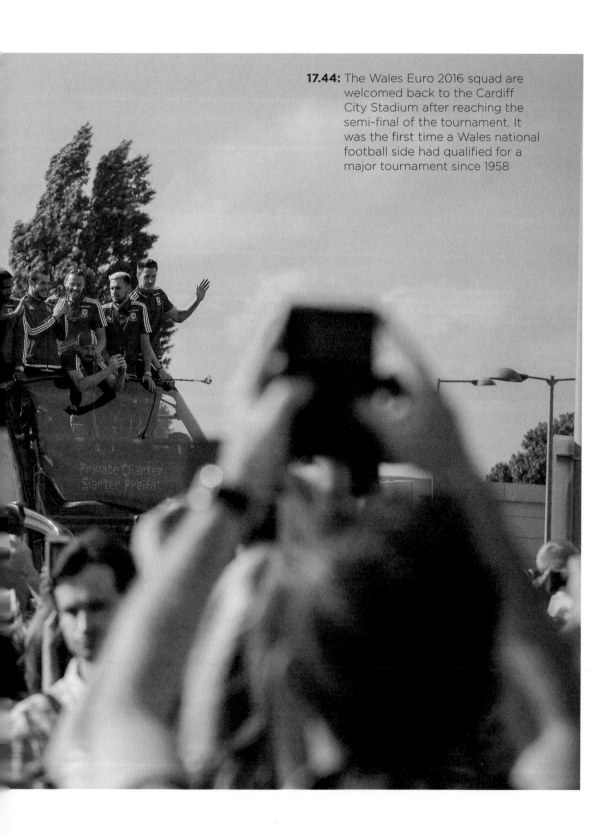

17.44: The Wales Euro 2016 squad are welcomed back to the Cardiff City Stadium after reaching the semi-final of the tournament. It was the first time a Wales national football side had qualified for a major tournament since 1958

21.46: A man and dog wait outside
St Catherine's Community Hall
polling station as the voting
deadline approaches in the
2017 General Election

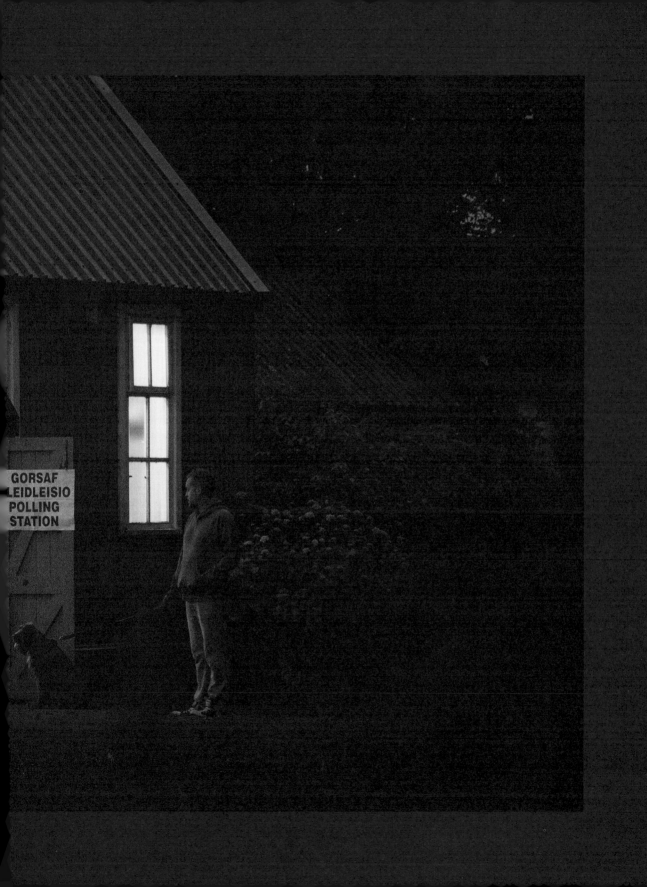

22.01: A polling station sign is removed from the door of St Catherine's Community Hall in Pontcanna as the voting deadline passes for the 2017 General Election

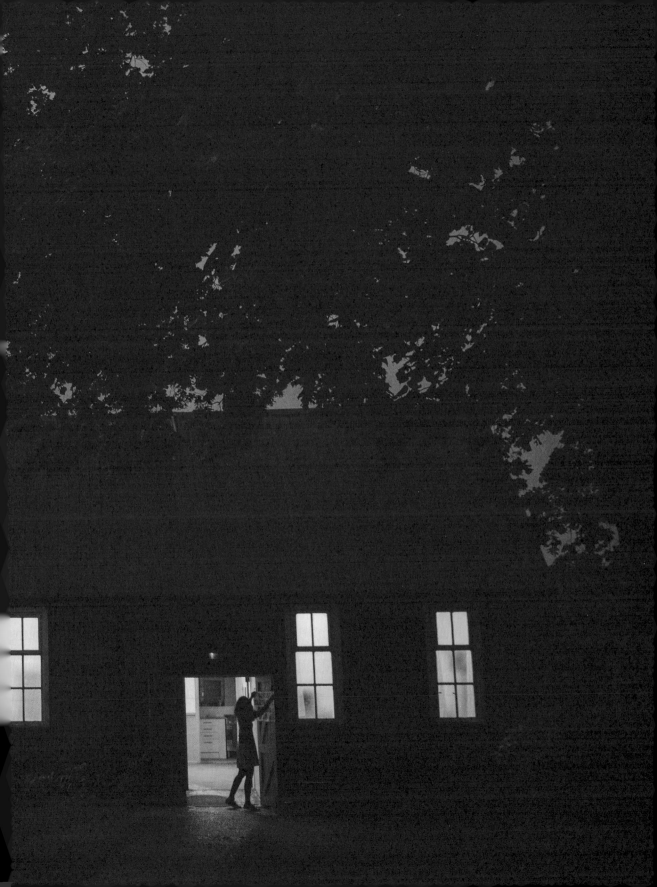

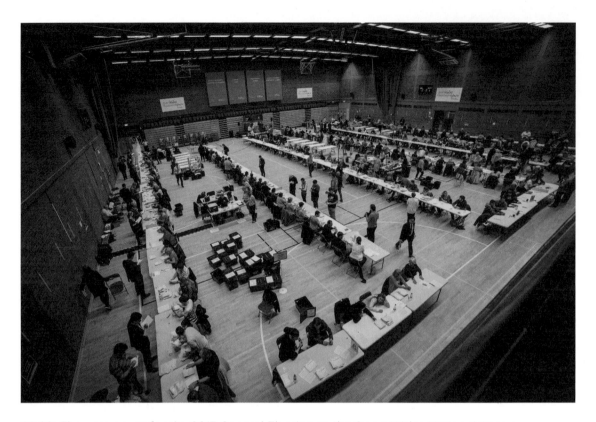

22.28: The vote count for the 2017 General Election at the Sport Wales National Centre, Sophia Gardens

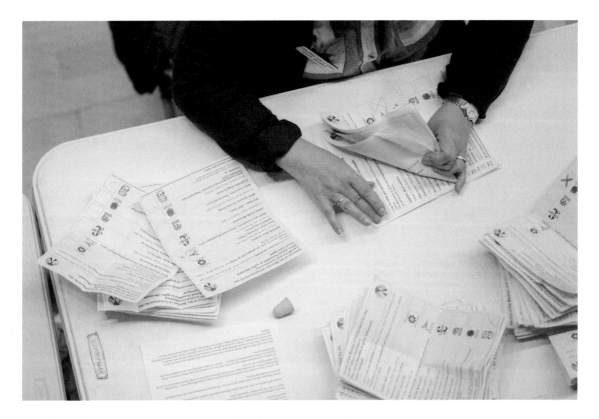
23.19: Voting papers are counted for the 2017 General Election

PARKS

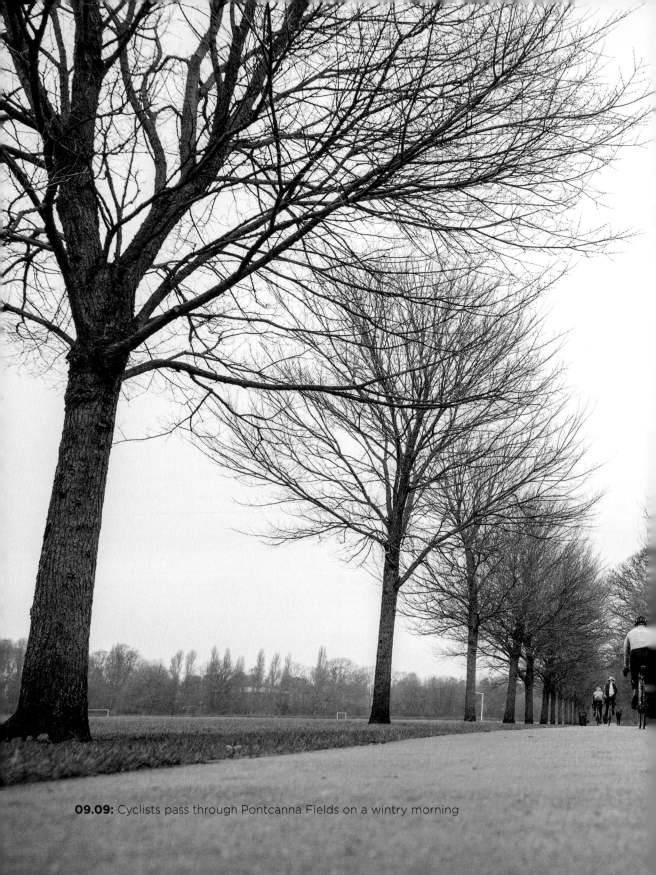

09.09: Cyclists pass through Pontcanna Fields on a wintry morning

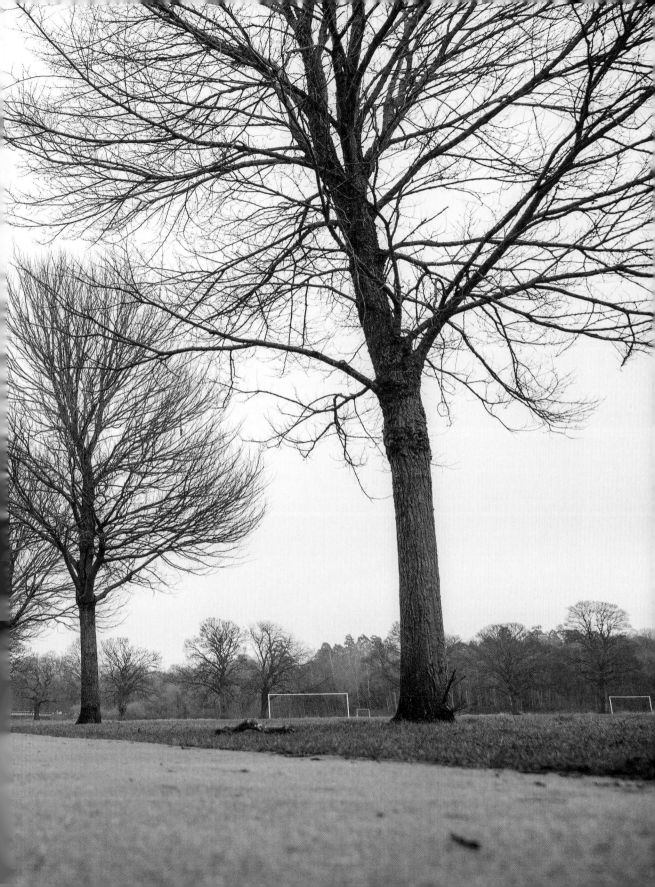

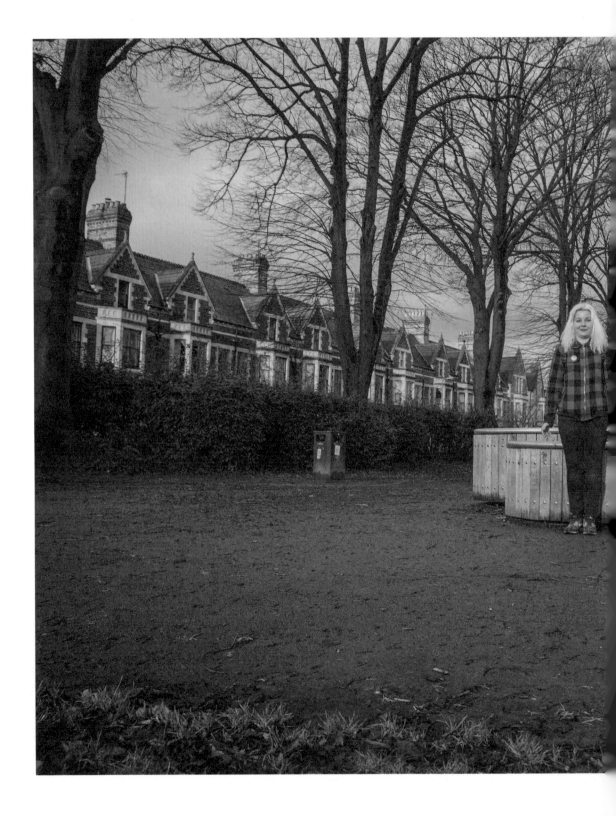

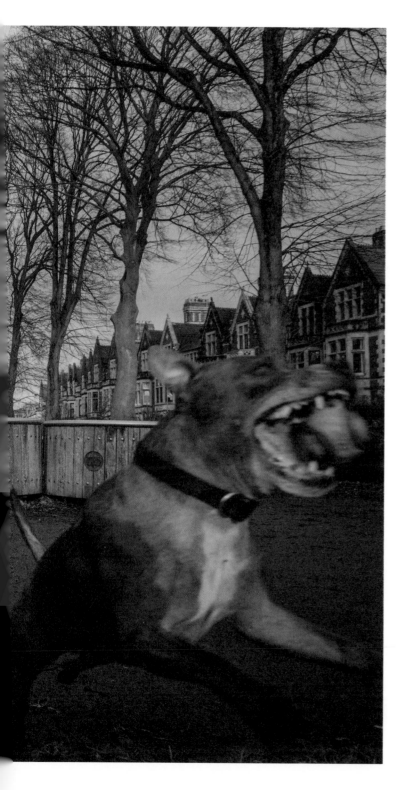

09.35: Laura from Pontcanna
Dog Walking
throws a ball for her
customer Milo

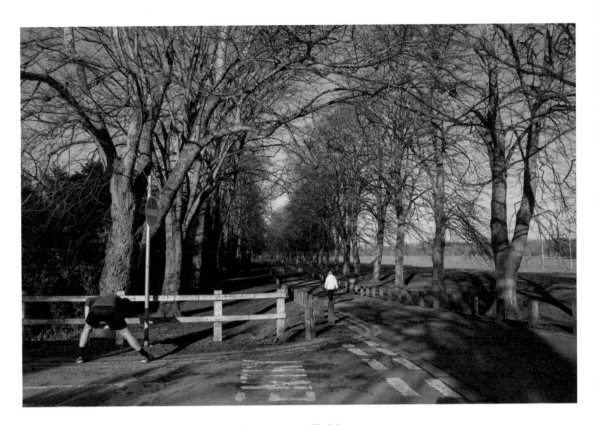

11.28: A runner stretches at one end of Pontcanna Fields

11.59: A fountain in Thompson's Park

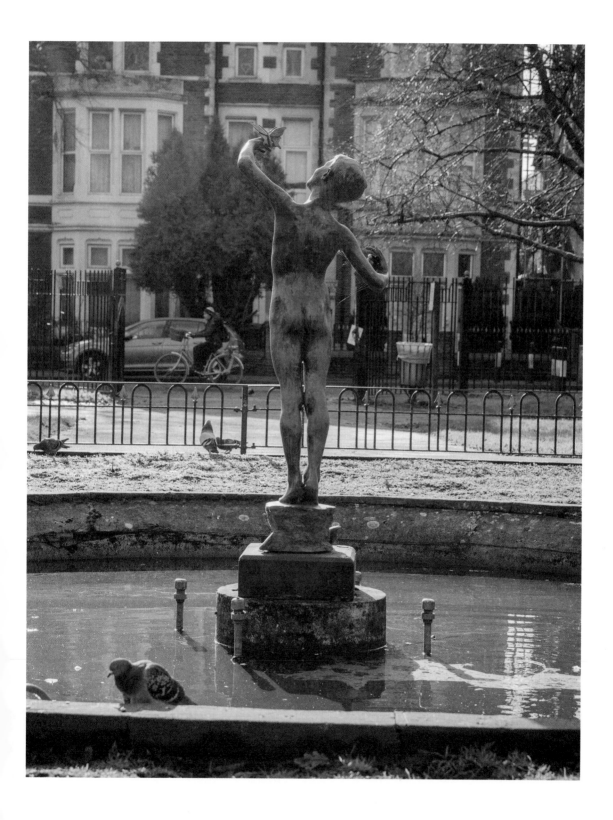

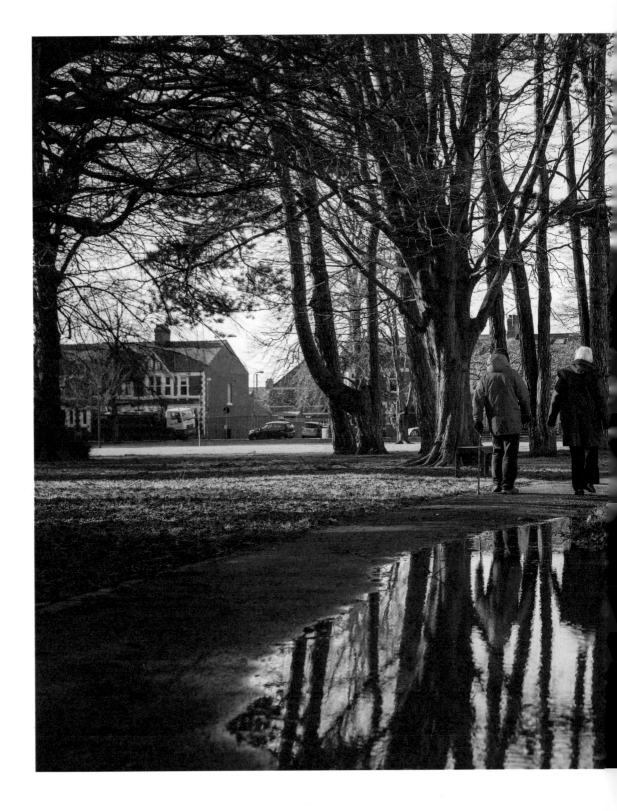

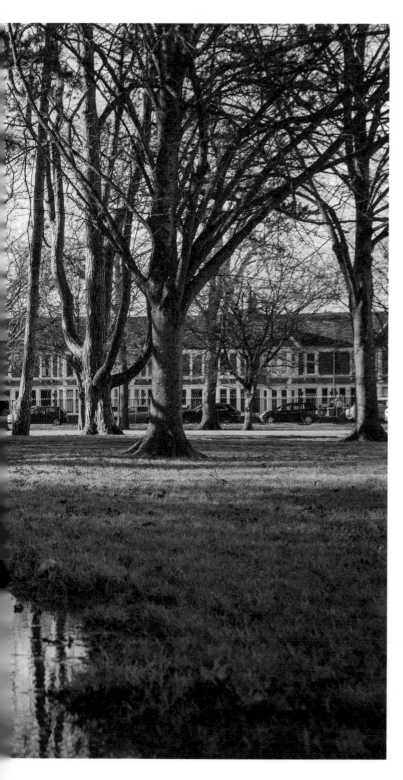

12.09: A couple wearing
waterproof jackets walk
through Victoria Park

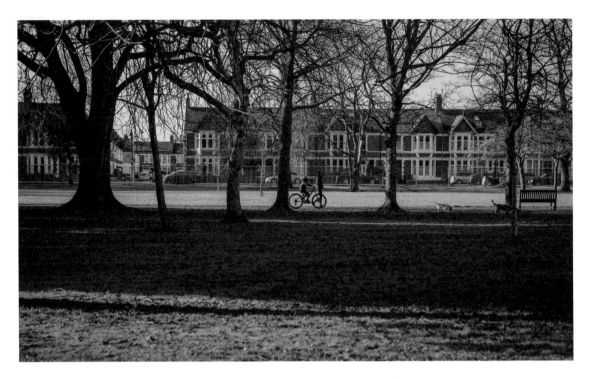

12.53: A boy cycles through Victoria Park with two dogs leading the way

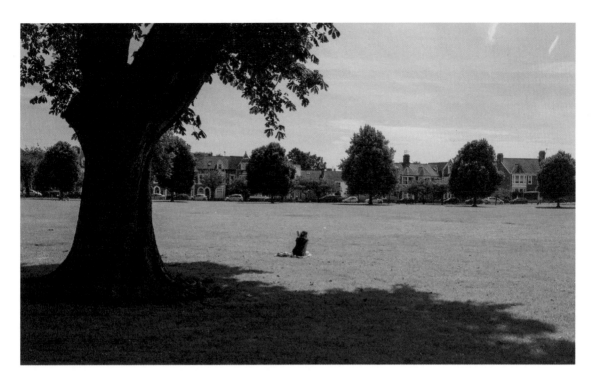

13.44: A woman reads a book in Llandaff Fields

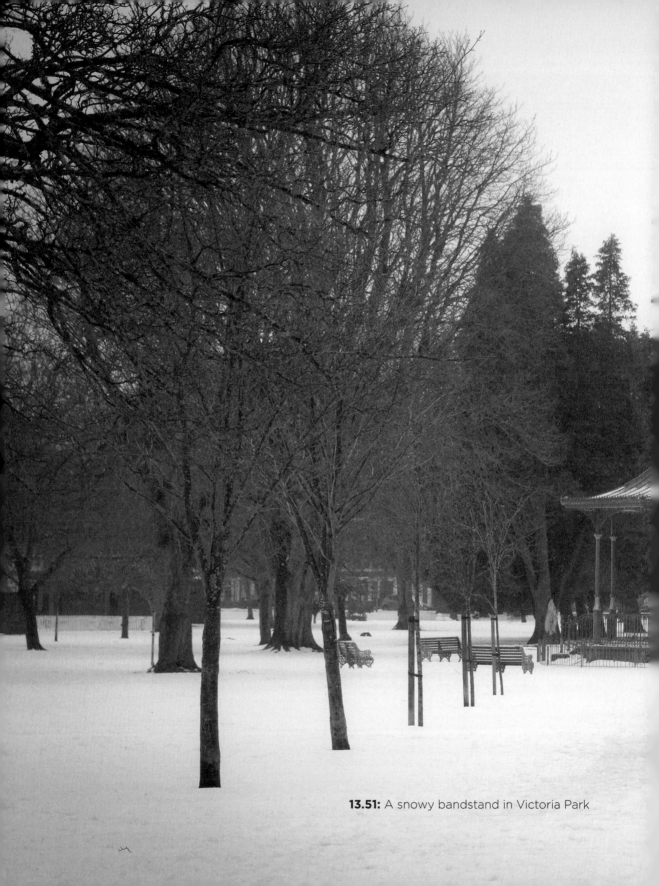

13.51: A snowy bandstand in Victoria Park

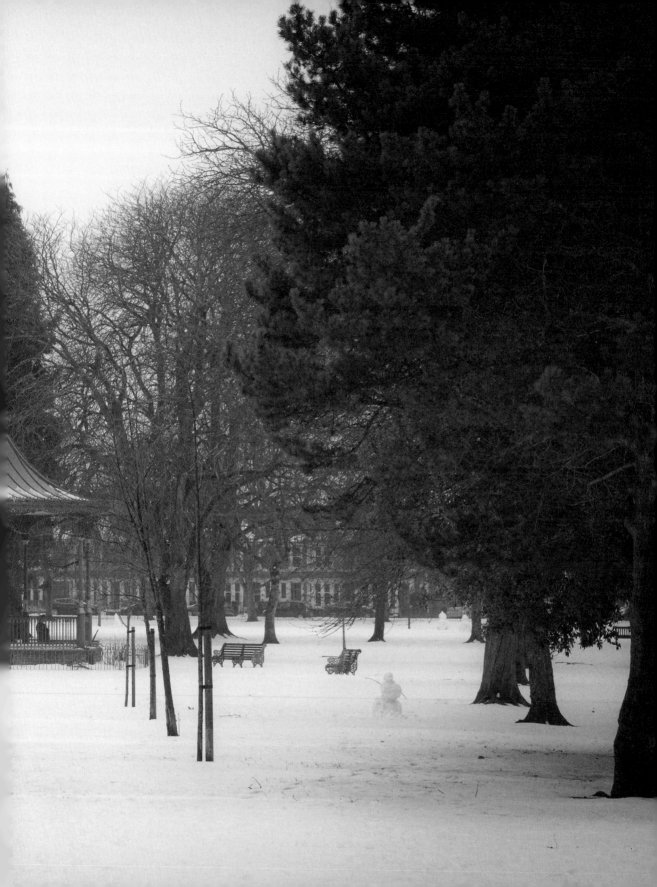

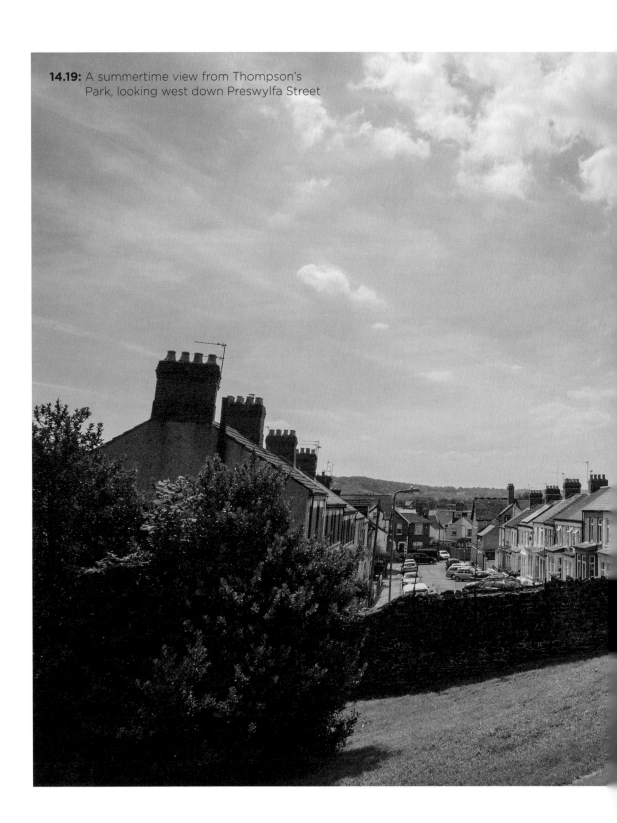

14.19: A summertime view from Thompson's Park, looking west down Preswylfa Street

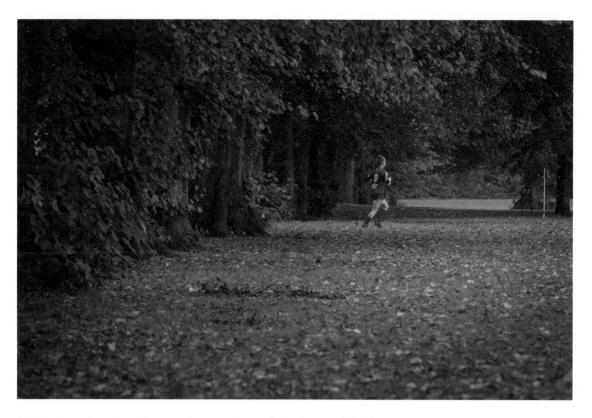

14.26: A rugby player jogs on to an autumnal Pontcanna Fields

15.34: A number of football matches are played at the same time across Pontcanna Fields

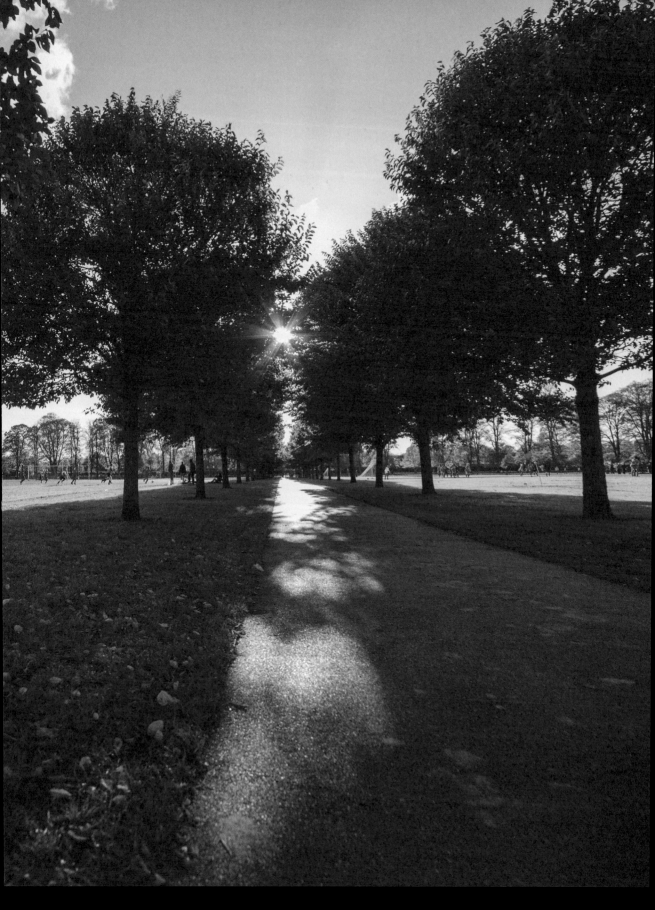

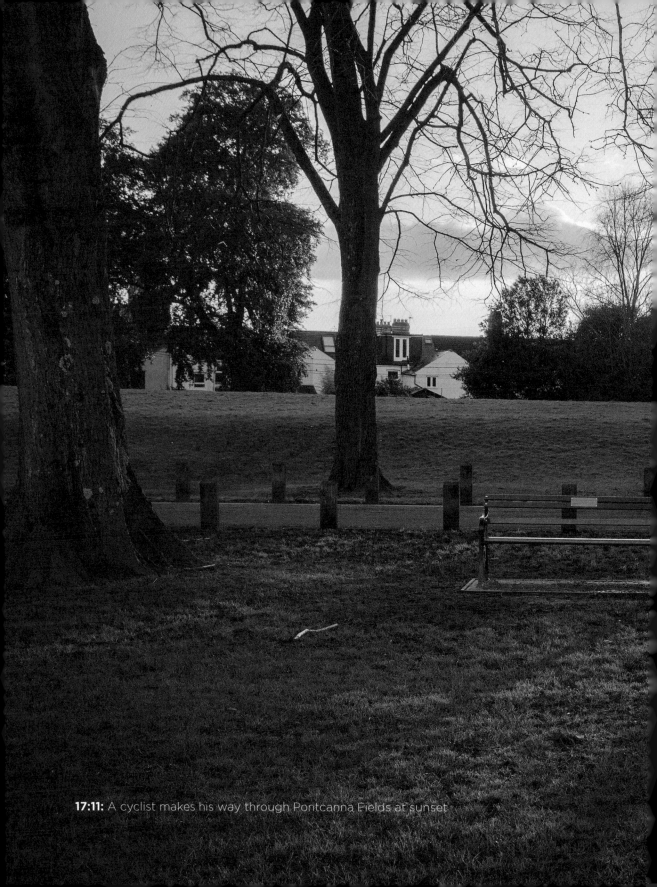

17:11: A cyclist makes his way through Pontcanna Fields at sunset

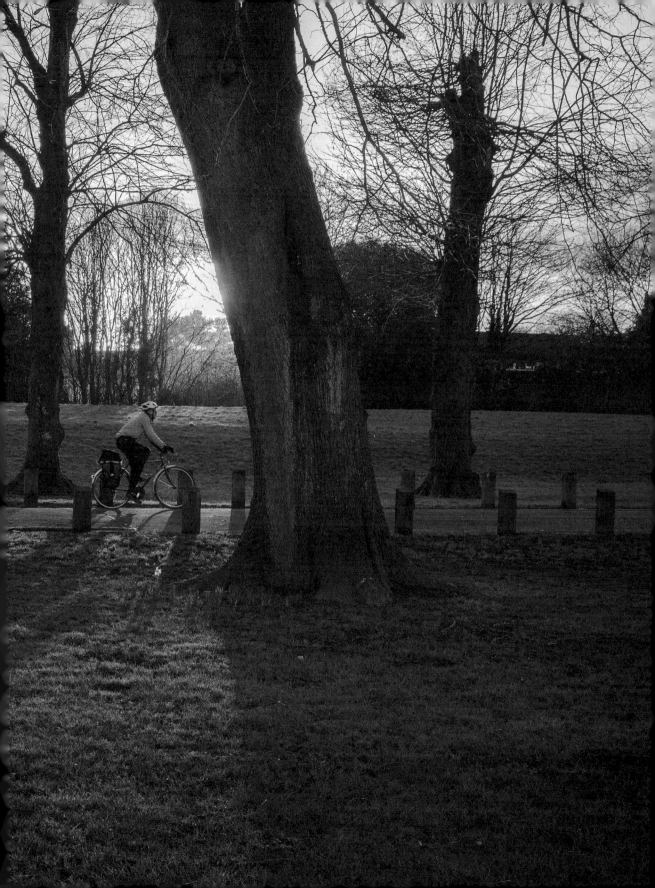

ACKNOWLEDGEMENTS

My sincere thanks go to the following people for allowing themselves to be photographed, for helping me to arrange shoots, or for giving me local tips: Khal, Laura from Pontcanna Dog Walking, Alice Burrows from Chapter, Phillip Zarrilli from the Llanarth Group, actor Sara Beer, Jay Robinson from Cardiff Ink, Will, Ahmed, Damien, Peter Finch, Canon Mark Preece, Sinead and Adam from Crafty Devil Brewing Company, Caroline Munro, Jan Williams, Martin Briggs, the residents and visitors of Canton and Pontcanna.